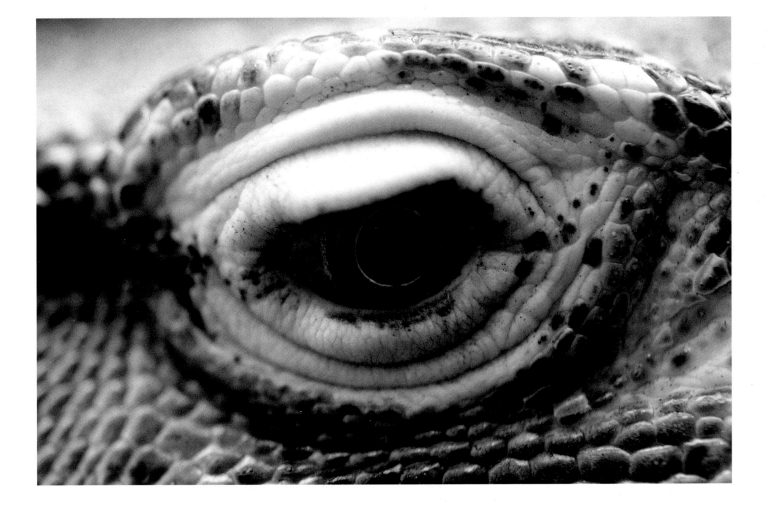

CREATURES

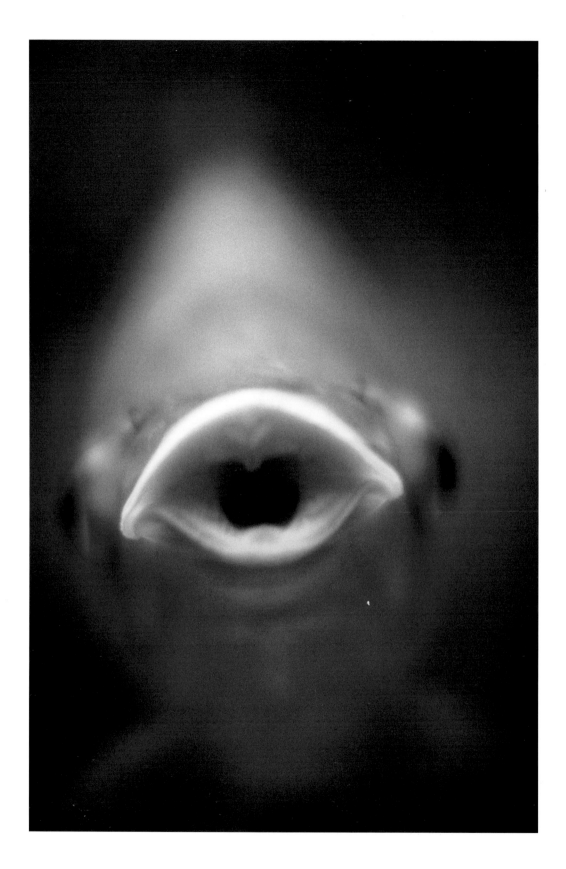

CREATURES
HENRY HORENSTEIN

INTRODUCTION BY
OWEN EDWARDS

Stewart, Tabori & Chang

New York

Published in 2000 by
Stewart, Tabori & Chang
A division of U.S. Media Holdings, Inc.
115 West 18th Street
New York, NY 10011

Distributed in Canada by
General Publishing Company Ltd.
30 Lesmill Road
Don Mills, Ontario, Canada M3B 2T6

Library of Congress Catalog Card Number: 99-76899

ISBN: 1-55670-986-2

Designed by Paul Langmuir
Production by Kim Tyner
The text of this book is composed
in Goudy and Gill Sans
Printed in Singapore by CS Graphics

10 9 8 7 6 5 4 3 2 1

First Printing

ACKNOWLEDGMENTS

The author gratefully acknowledges
the contributions of . . .

Agfa Corporation
Randall Beek
Bonni Benrubi Gallery, New York
Peter Broderick
Barré Bullard
David Caron
Cynthia Charron
John Cleary Gallery, Houston
Jan Cox
Megan Doyle
Kathleen Ewing Gallery, Washington
Thomas Gearty
George Gibson
Julia Hallowell, Ginsburg Hallowell Fine Art
Robert Klein Gallery, Boston
Michelle Kloehn
Paul Langmuir
LewAllen Contemporary Gallery, Santa Fe
Sal Lopes
Sara Morthland Gallery, New York
Brian Nelson
Maggie North
Photonica, New York/Tokyo
The Platinum Gallery, New York
Andrea Raynor
Amy Rhodes
Jane Roberts
Linda Rohr
Susan Titus
Amy Townsend-Small
Phil Trager
Dot Wensink
Eelco Wolf
Zona, Boston

INTRODUCTION

THE SECRET LIFE OF CREATURES
BY OWEN EDWARDS

This book, like the best of art, is not what it may at first appear to be. It is not, in other words, a book of photographs of animals. There is no shortage of those, and some are very good, but Henry Horenstein is giving us something emphatically different. The key to his unique view of the world in these pictures can be found in the word he has chosen as his book's title: Creatures.

Unlike words such as "animals," "fauna," the fairytale "beasties," or the fairly awful neologism "biomass," the word "creatures" carries with it an aura of ancient magic, the mysteries that emerge from the long shadows of primordial myth. Creatures are those ominous, numinous things conjured out of firelight by shamans in feathers and paint. Animals, on the other hand, are what we see every day, in our house cats and pet dogs, in Audubon calendars, and on the countless nature shows that are the public television equivalent of syndicated game shows. Creatures are different; creatures live in the world, and at the same time in the dark recesses of the mind. With its kinship to "creation," the word "creatures" evokes the strange, chaotic abundance of life, and the equally astounding menagerie that roamed the savannahs and forests of the human mind in a time when all sorts of unknown things went bump in the night. Even today, when we presume to know everything, "creatures" takes us back to a time of dragons, mermaids, centaurs, winged lions, minotaurs, unicorns, sphinxes and all the myriad monsters that lurked at the edge of the ocean sea. In the modern world, a place of extinctions, both in the real world and in the imagination, few of these legendary beings survive. The Loch Ness Monster, the Yeti and Sasquatch, are about all that remain of a once wondrous bestiary. And as the glare of reason and knowledge lights the farthest corners of once-dark woods, we sense a certain emptiness.

Horenstein seems to feel this emptiness too, but he has found a way to fill it. He hasn't gone off to the highlands of Scotland, or the Himalayas, or the last great forests of the American Northwest in the vain hope of finding one of these last mysteries. Instead, he has stayed in cities, going to the zoos and aquariums. There, like everyone else, he looks in comfort at the most voraciously observed of the earth's animals, once wild and amazing things that have had their capacity to astonish worn smooth by the countless thousands of stares. Through the transformation of his camera's eye, these familiars become, once again, fabulous creatures.

Seeing is seeing, but photography is re-seeing. In the early days of the medium, when making pictures was difficult, any image brought back from the mountains and the deserts was new and unusual. But photography is the most voracious of arts, always ready to cannibalize its past, so seeing things differently becomes more and more difficult as time passes; the world, it now seems, has by now been seen, re-seen, and re-seen yet again. Thus, though most

photographers are driven to find a new vision, even the best fail more often than they succeed. In Creatures, Henry Horenstein has succeeded to a dazzling degree, evading the abundant cliches of animal photography at every turn. To accomplish what Eduard Steichen once referred to as "kicking the tripod," Horenstein moves implausibly close, blurs focus, and gives a portraitist's formality to dogs, whales, turtles, and orangutan toddlers. He isolates odd details—the eye of a Komodo dragon, walrus whiskers, the slightly goofy "smile" of cownose ray, the suction cup toes of a gecko—and reminds us powerfully what a marvel the variety of life on earth is. As Horenstein examines nature in his more-than-slightly peculiar way, he presents us with the infinite fertility of evolution's imagination.

As is often the case in photography, chemistry and circumstance led to these pictures at least as much as any muse descending. Horenstein found himself in zoos on assignment, making straightforward color pictures of baby animals commissioned for a children's book. He had recently been experimenting with a new film for making black and white slides which, when made into Cibachrome prints, created an alluring depth and dimensionality. To keep his days interesting, Horenstein began making a very different personal series of pictures with this film, matching the mystery of his creatures with the moody quality of the resulting prints. "The Cibachrome gave me a pure effect, with almost all the color stripped away," he says. "The prints drove the project."

If chemistry was a driving force, a certain psychic comfort with the surroundings also played a part. Simply put, Horenstein likes zoos. "I remember being taken to a zoo when I was a little kid and seeing a cow milked," he says. "To a city kid, that was incredibly exotic. Now, when I watch kids gather around the glass at a zoo to look at reptiles in a way they ordinarily never could do, I'm reminded of that experience. If you get close to animals, they become something entirely different, in the same way a person can become different when you get very close. Compared to someone who goes up to the ice floes to photograph polar bears, I feel like a slacker. But a zoo or an aquarium gives me a chance to see very differently."

Beyond the particular magic of his process, and the general magic of his way of seeing, Horenstein's ambition for these images is refreshingly uncomplex. As a teacher he hears "a lot of intellectualizing about pictures." So as he prowled through any number of zoos, he wanted to make photographs that had no profound meaning beyond the feelings they aroused. "These pictures are about sensuality, strangeness, basic human emotions, and even creepiness."

In Henry Horenstein, the creeping, crawling, swimming, barking, growling, finned and fearsome creatures of this still-teeming earth could have no better chronicler.

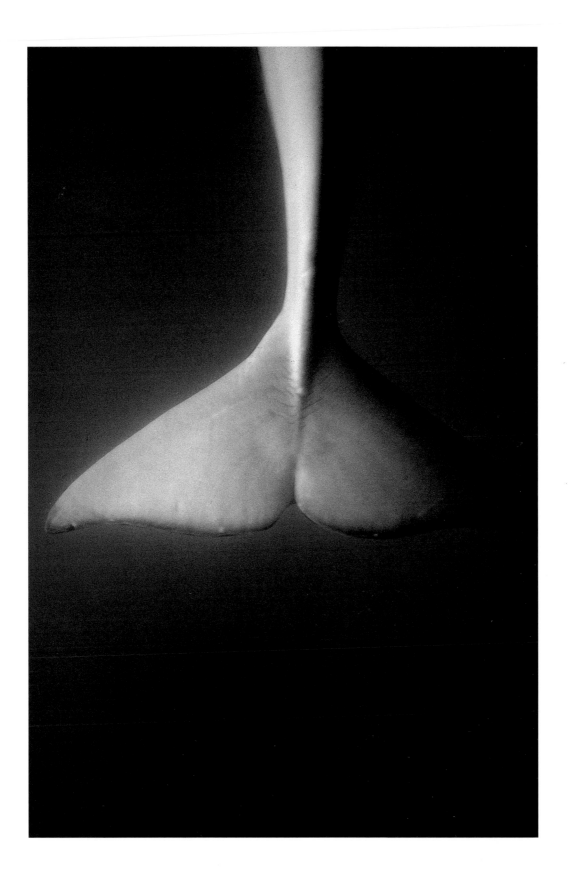

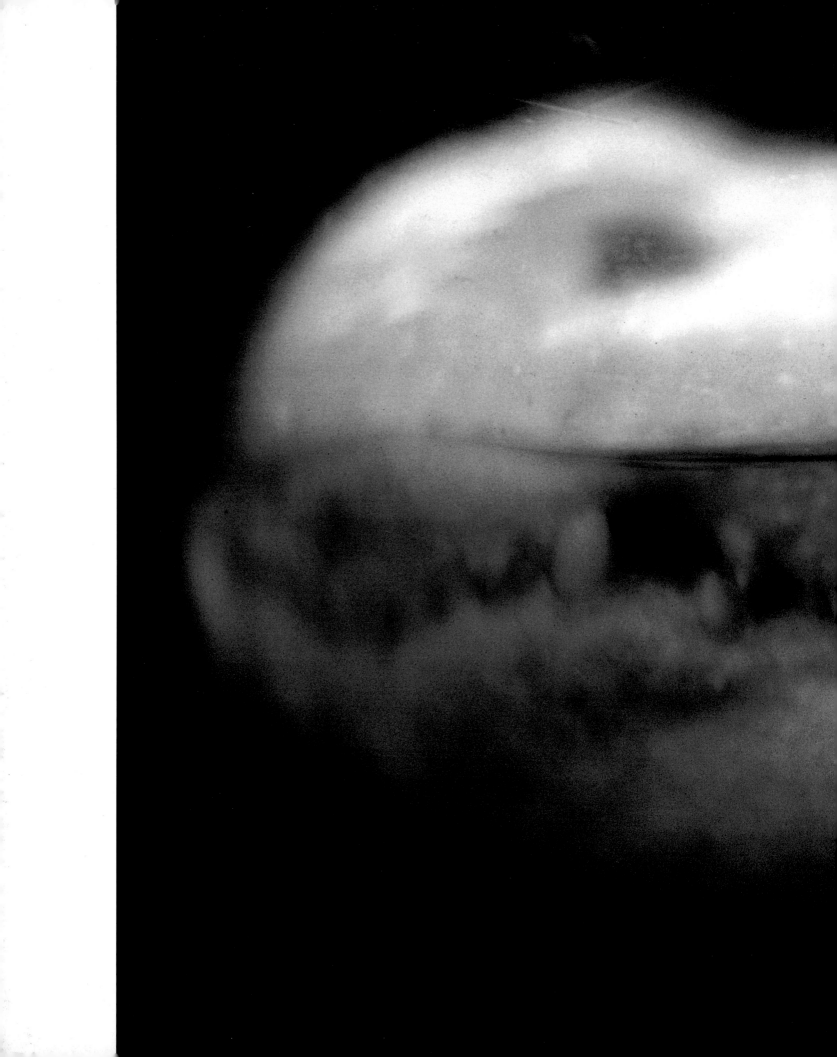

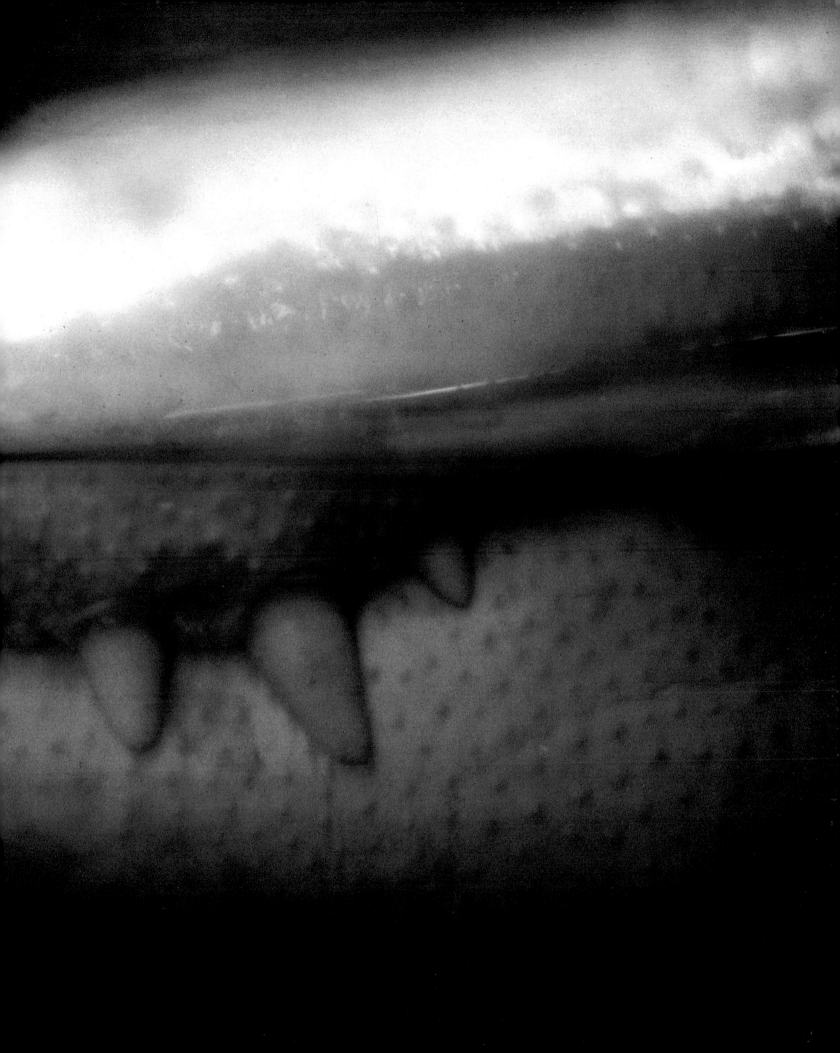

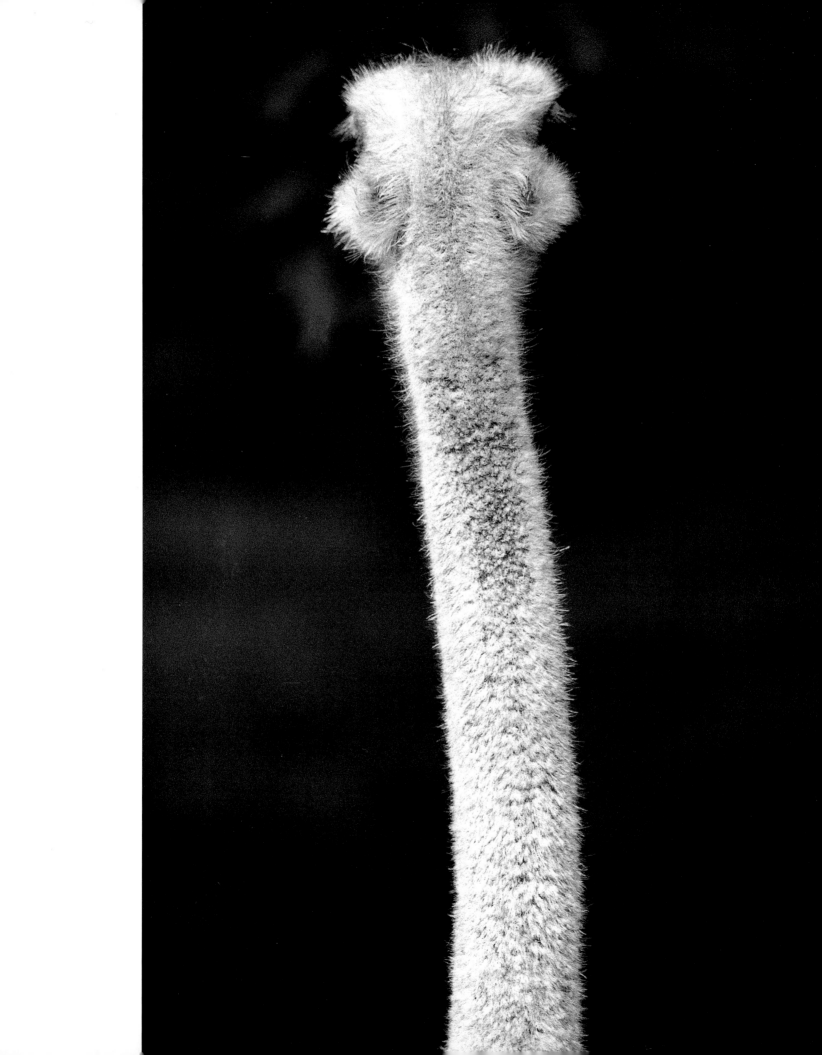

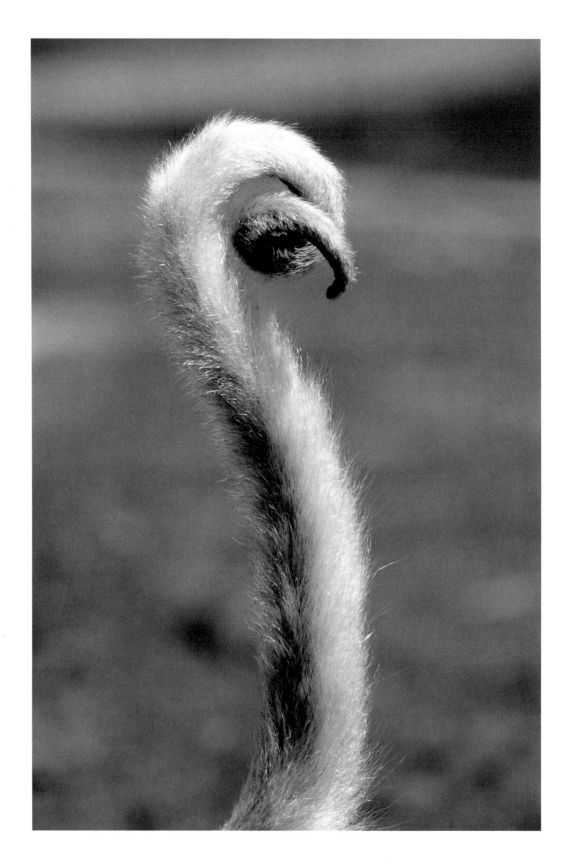

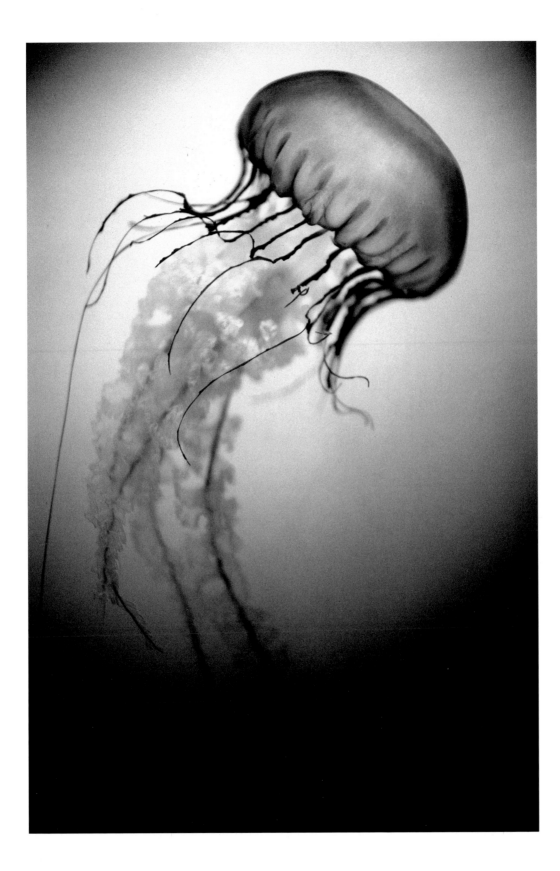

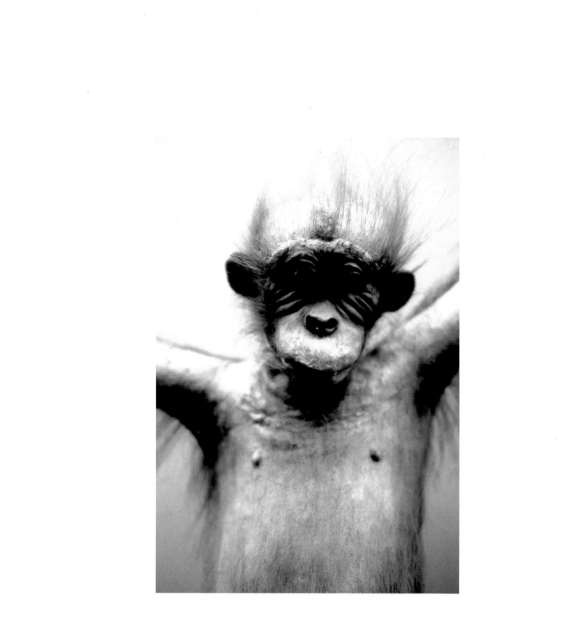

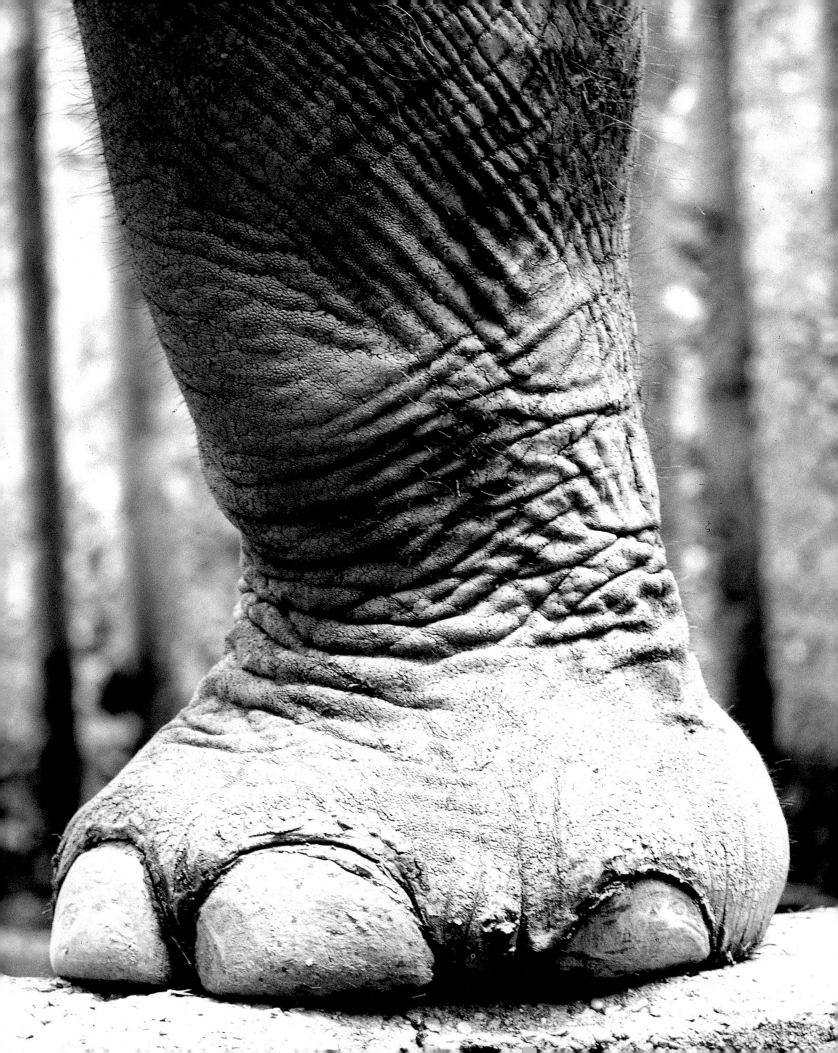

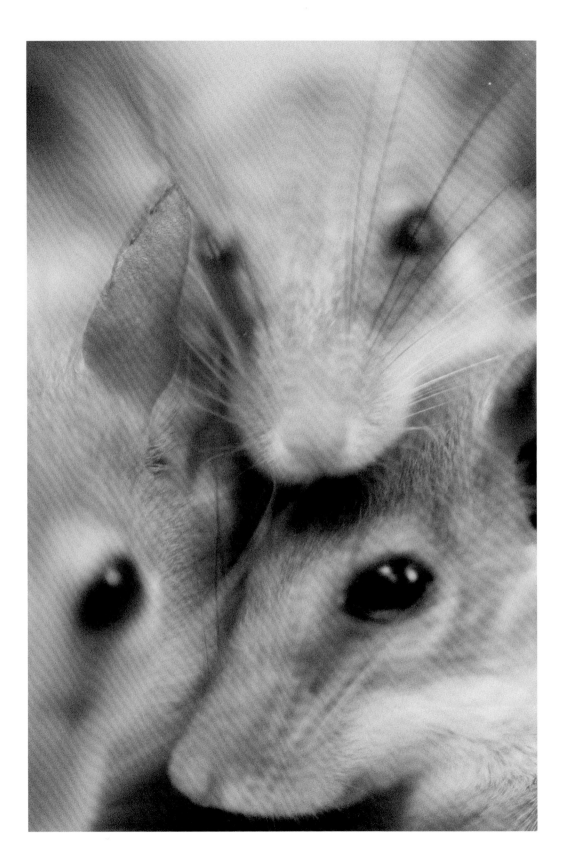

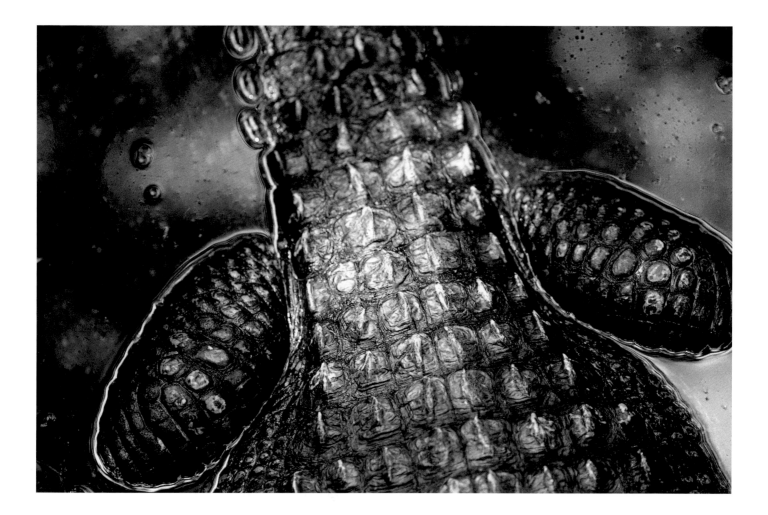

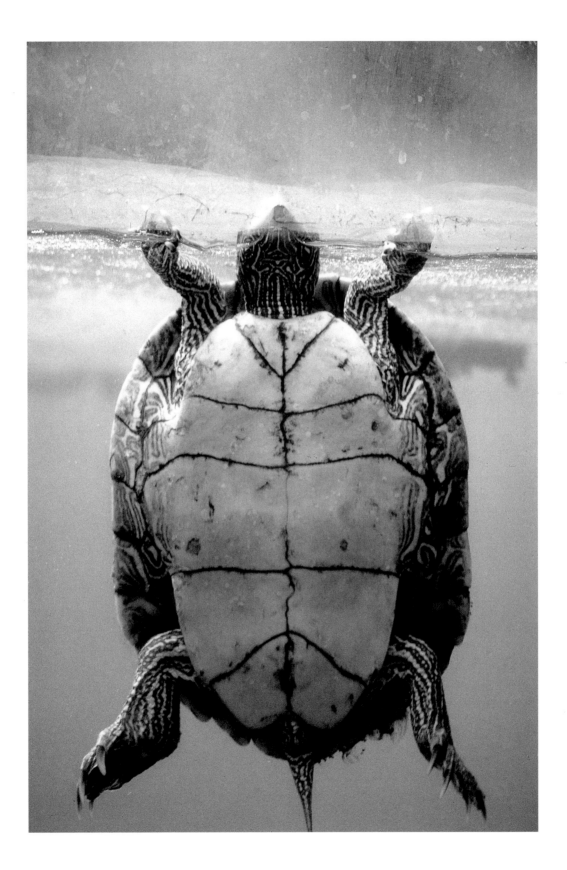

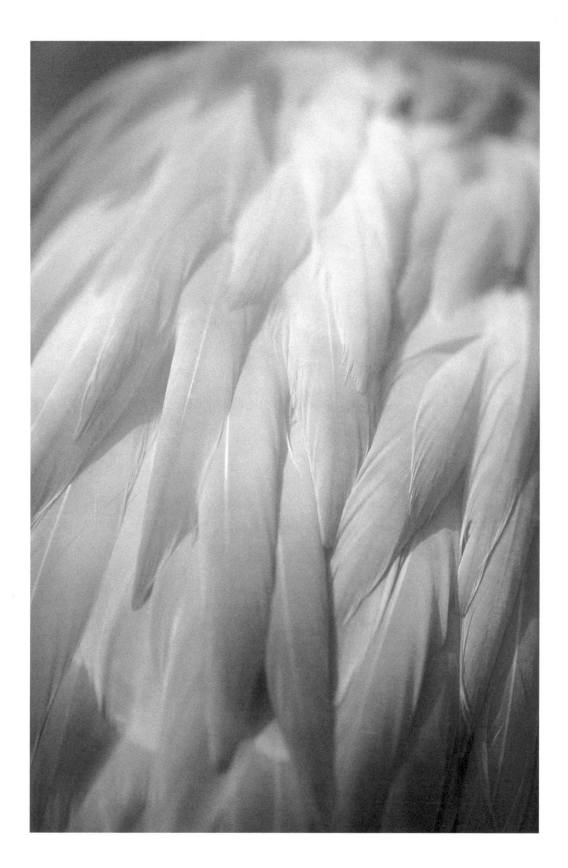

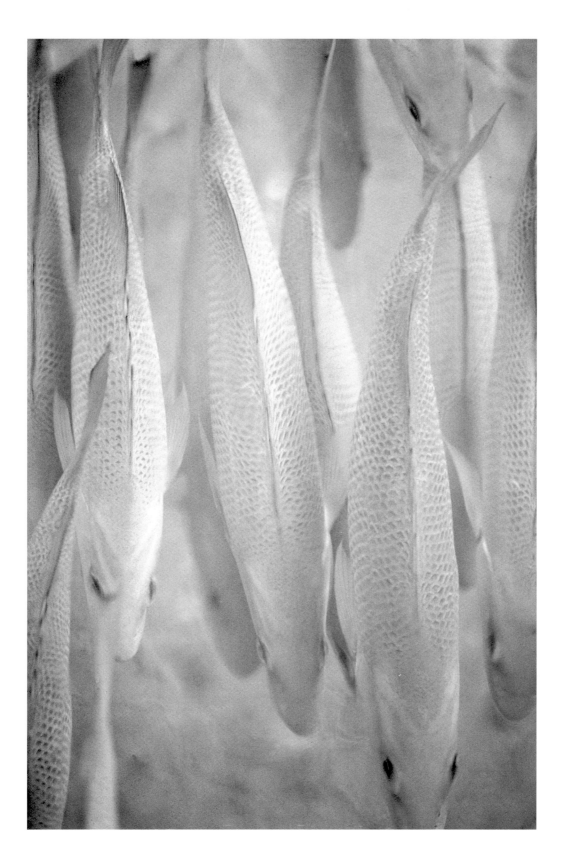

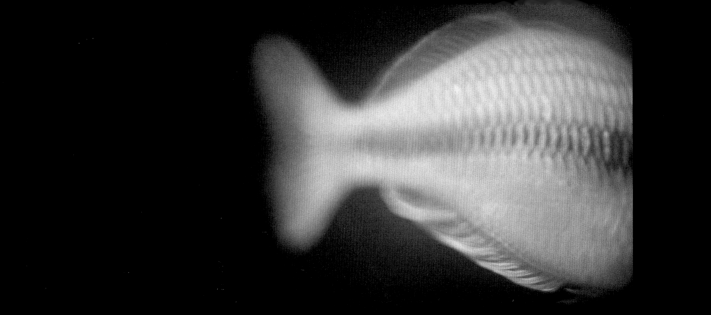

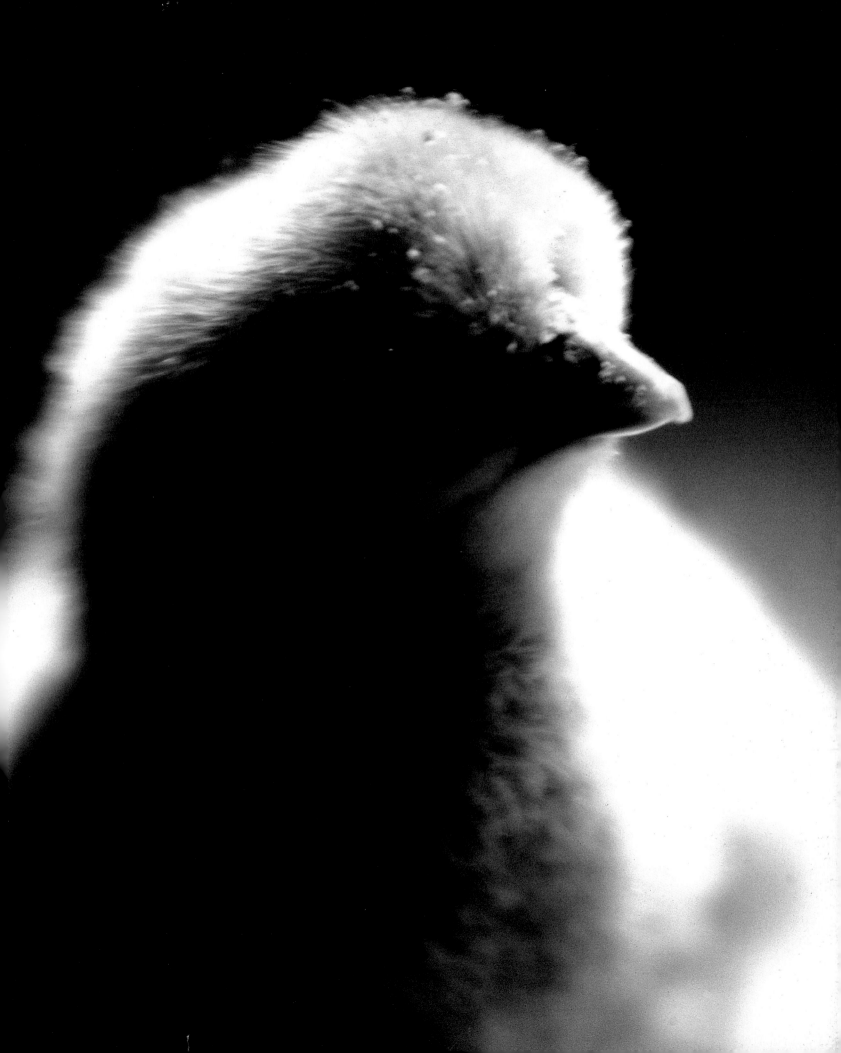

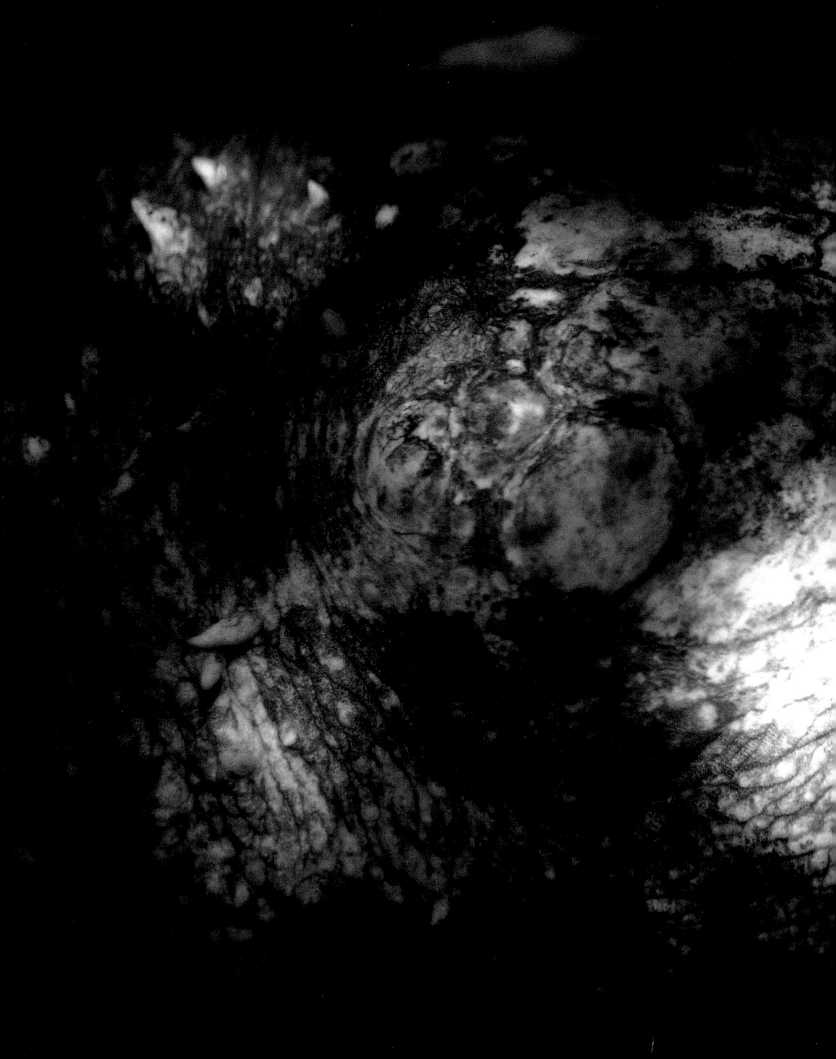

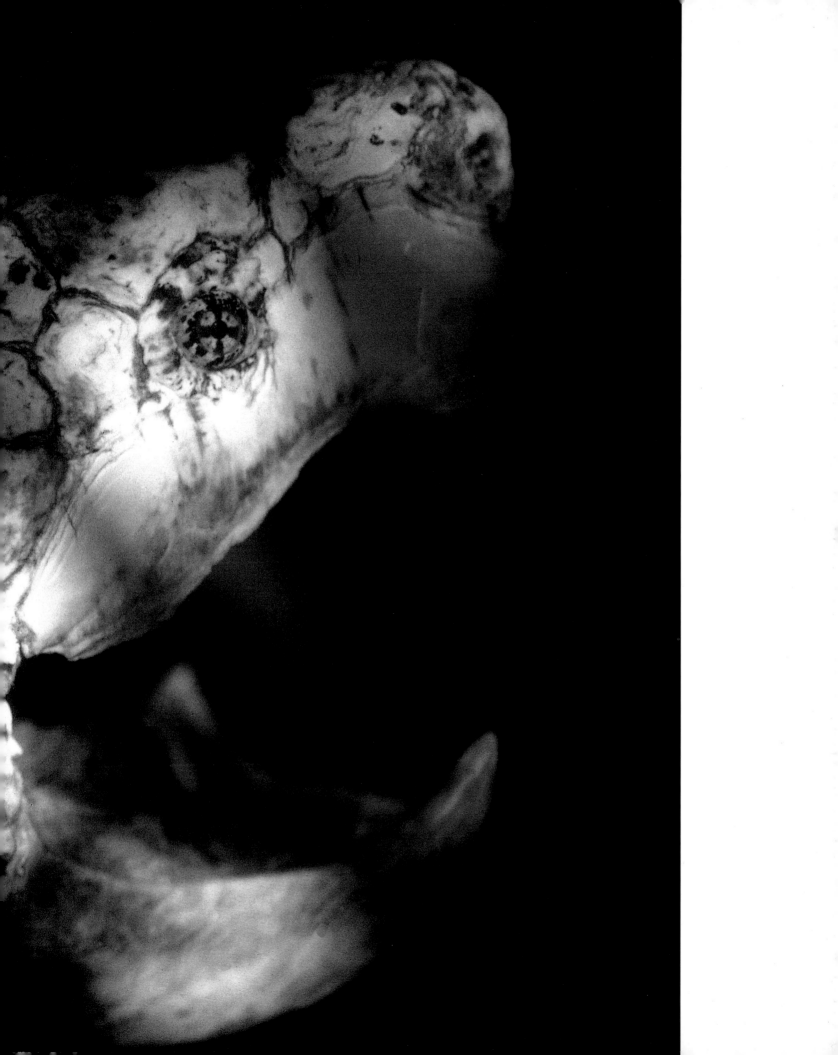

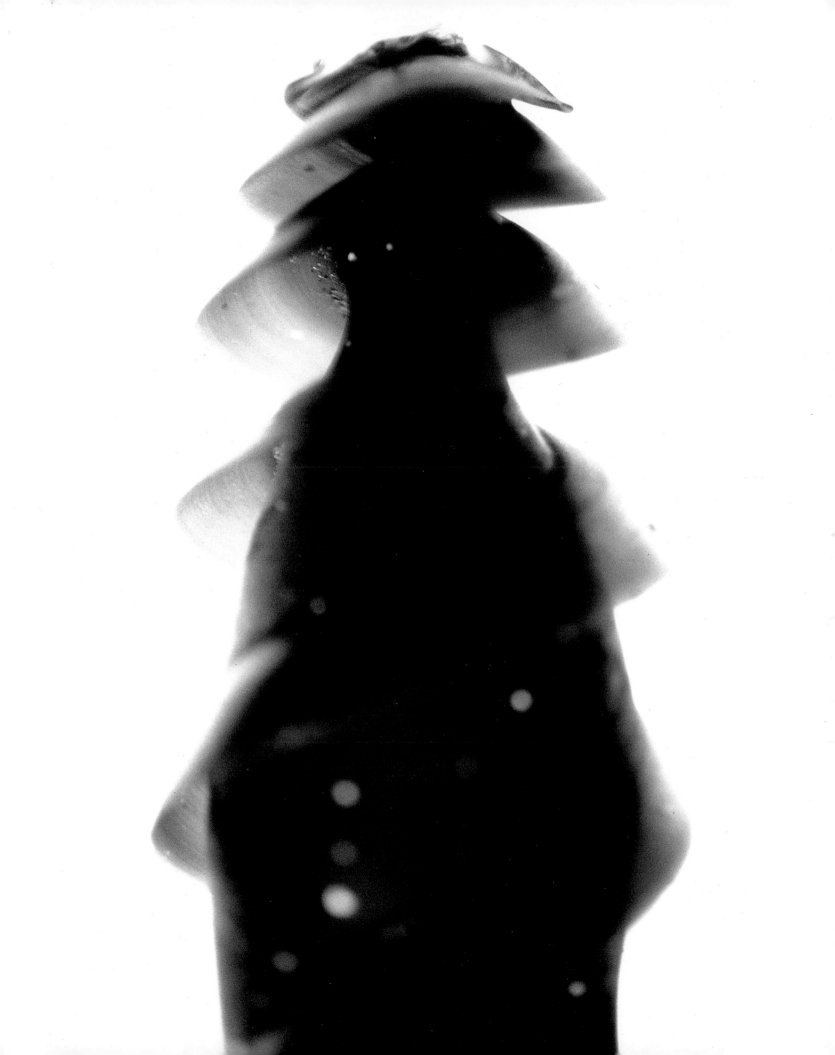

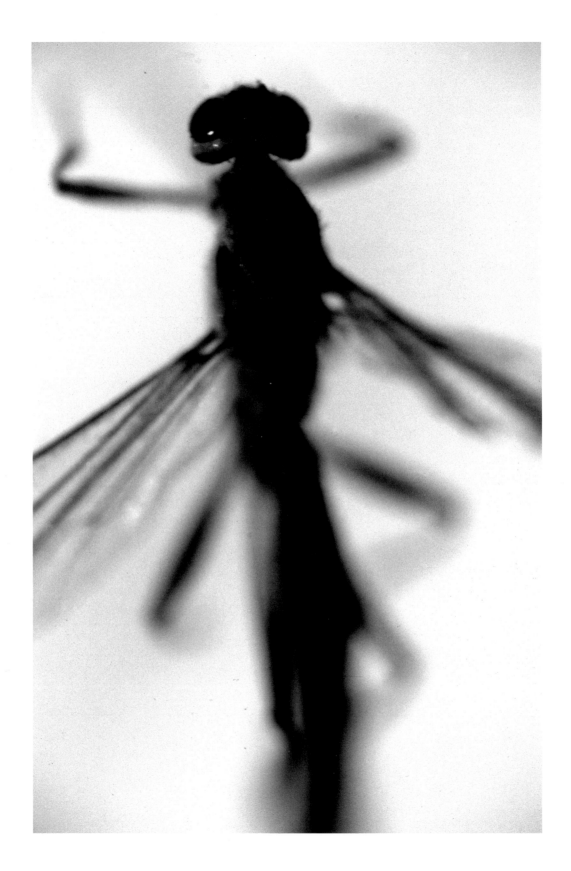

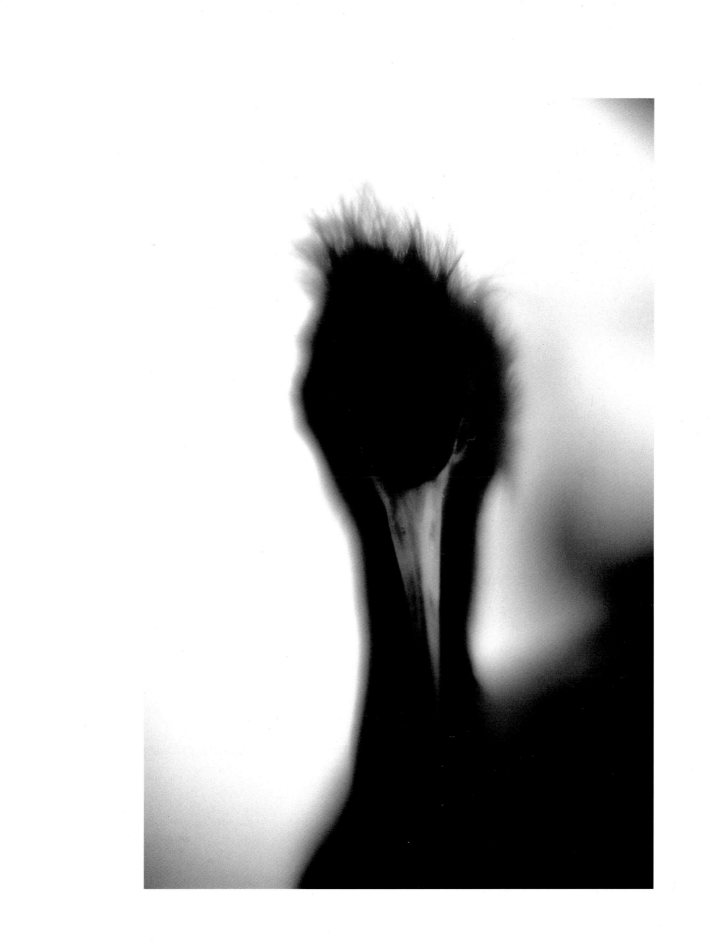

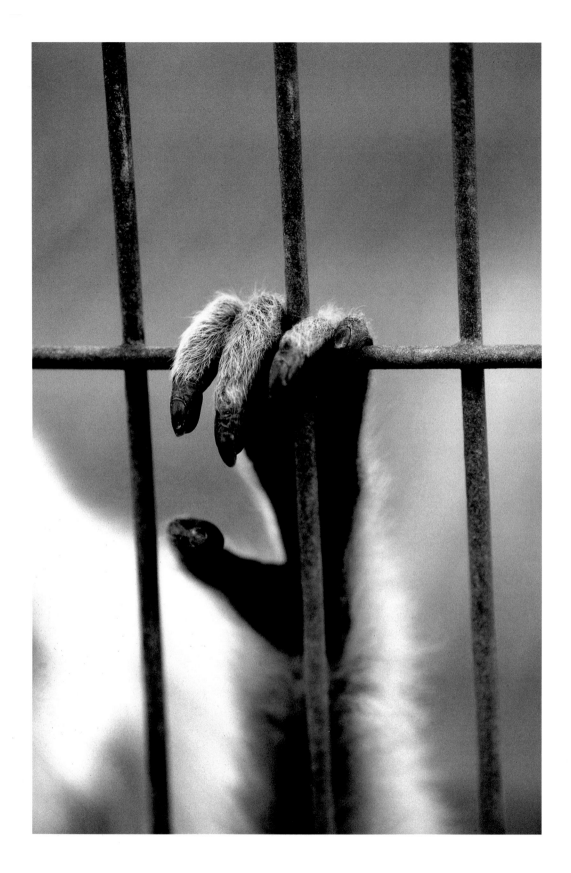

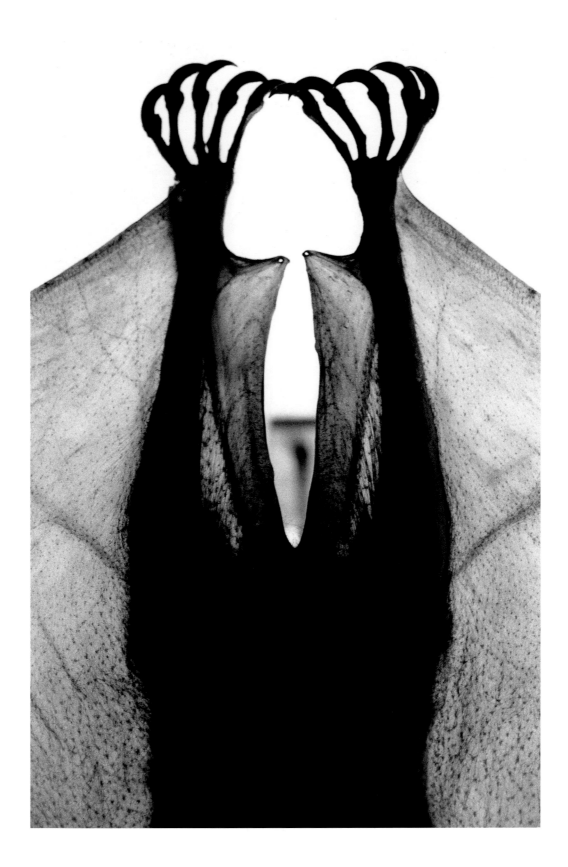

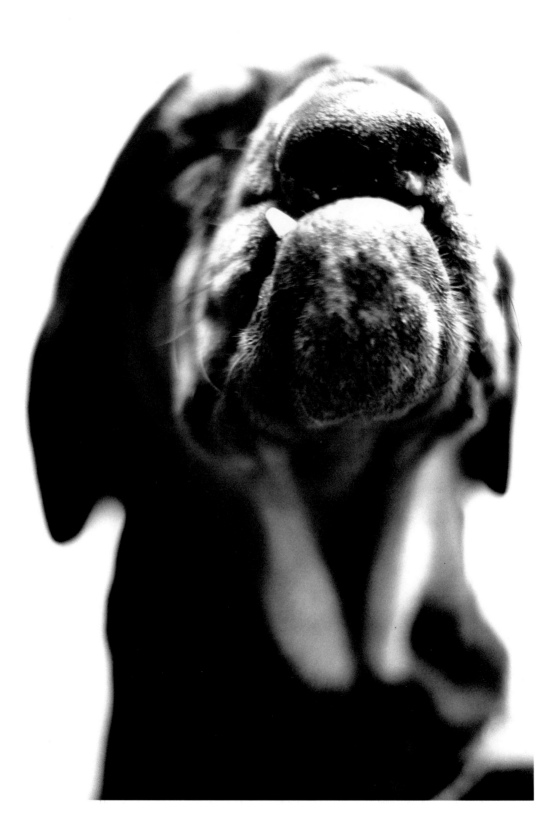

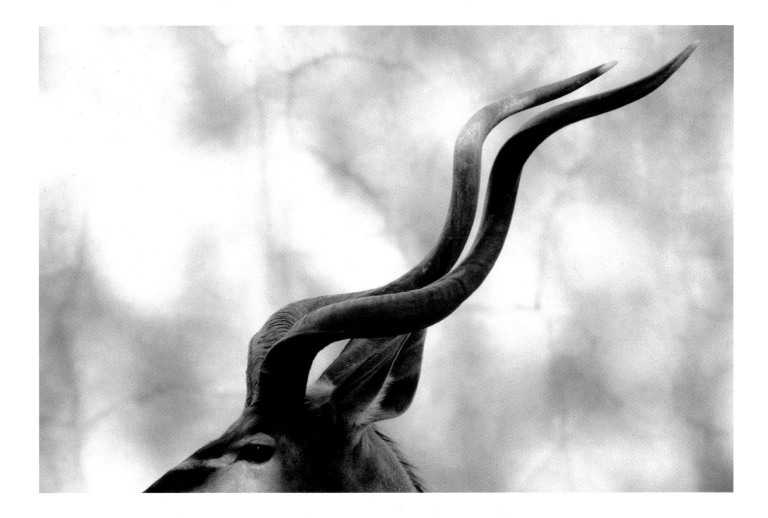

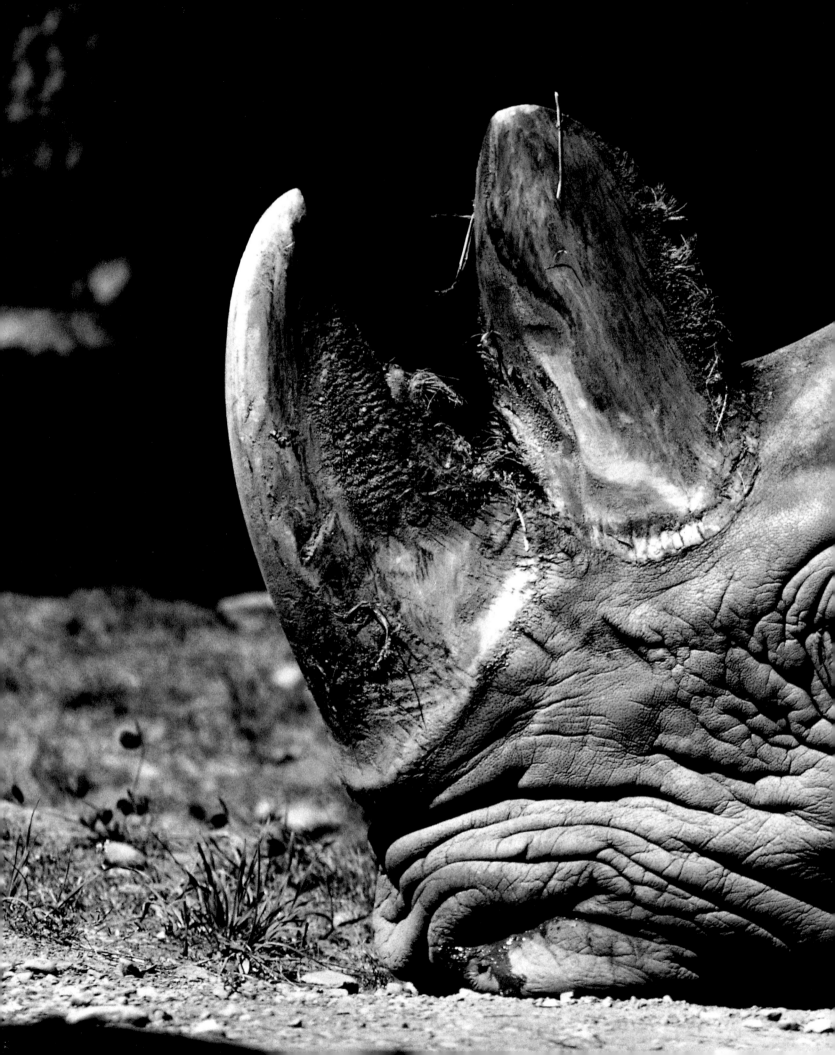

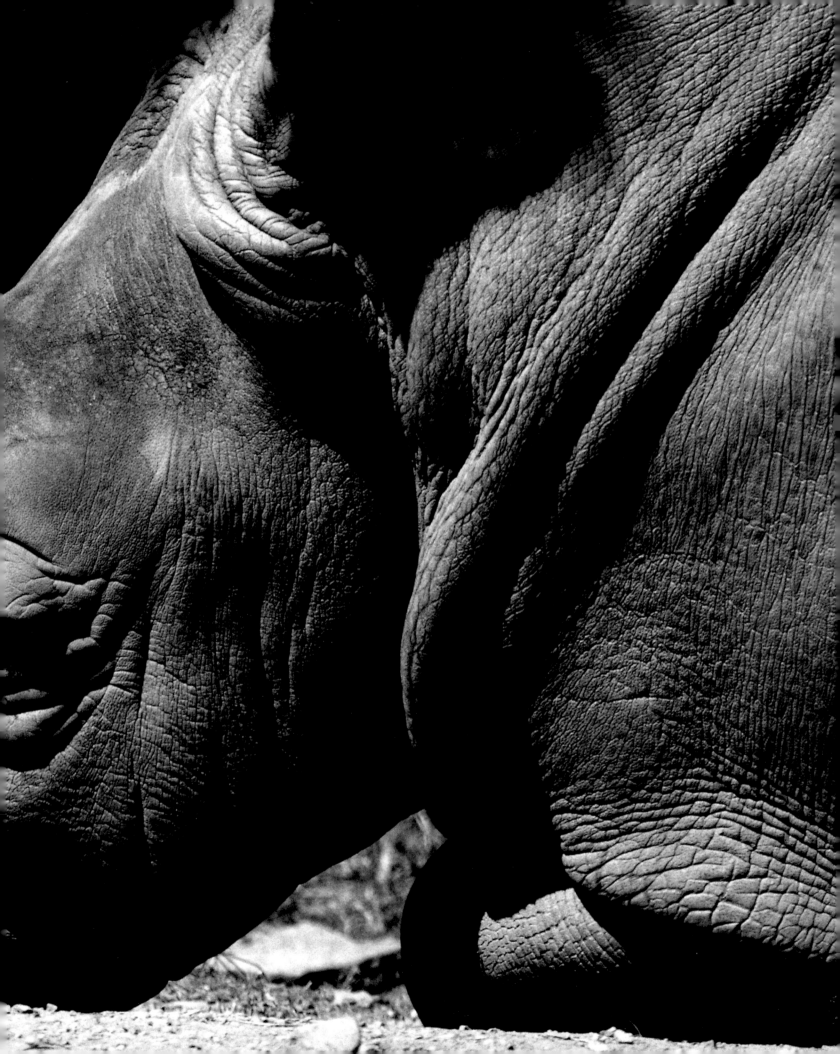

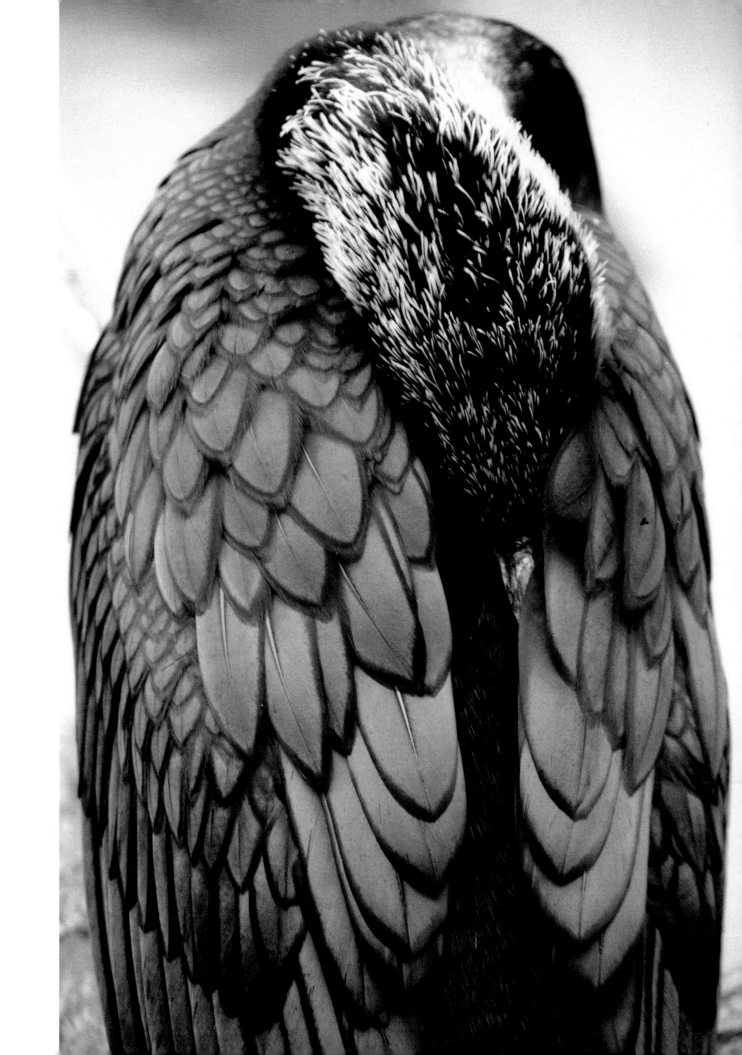

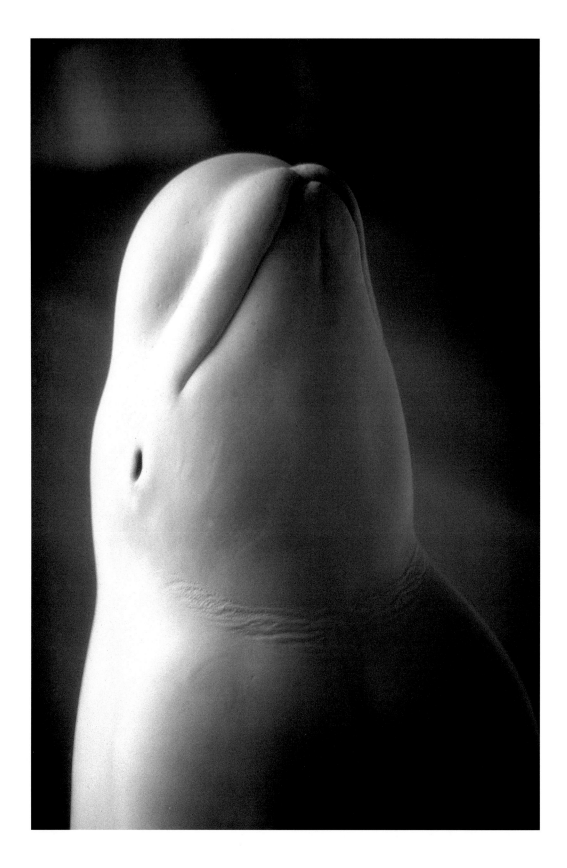

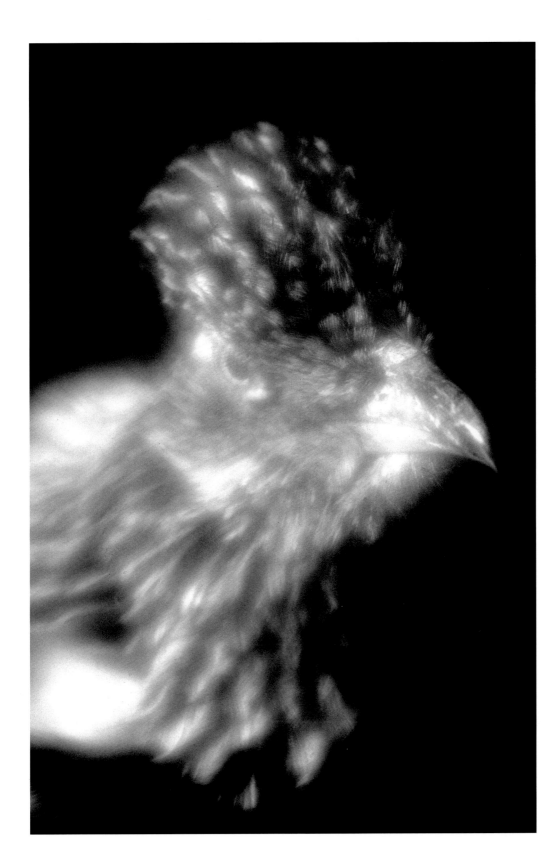

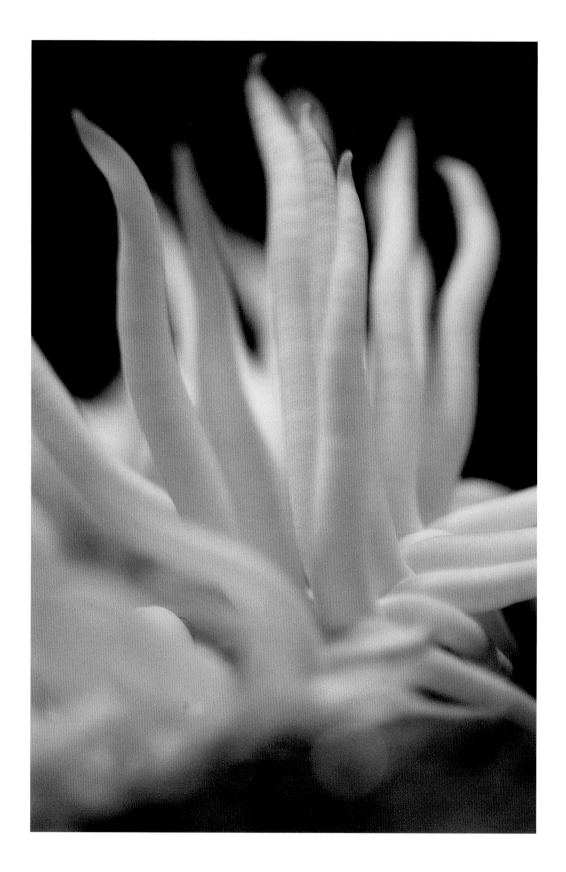

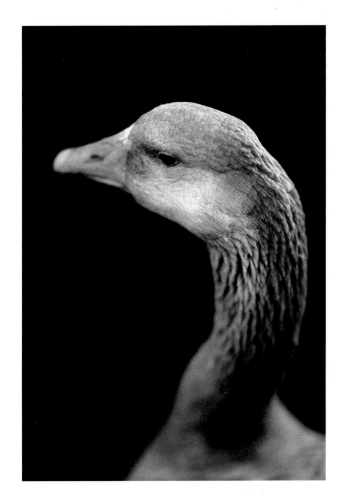

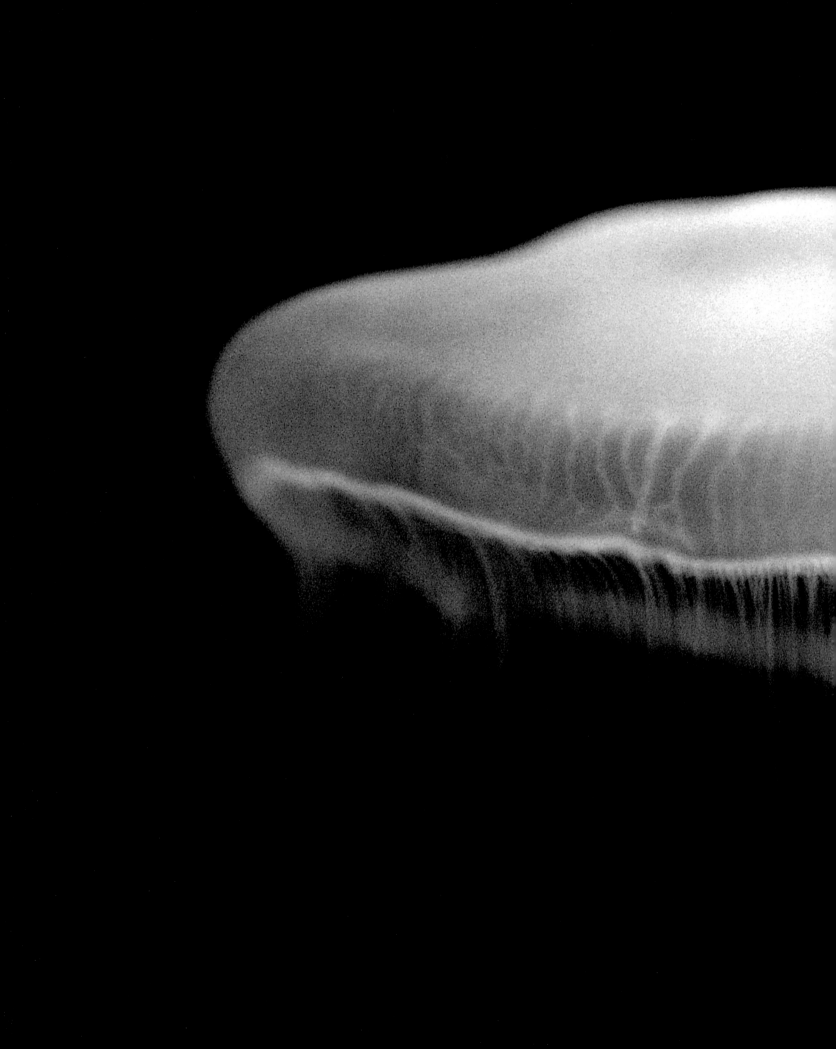

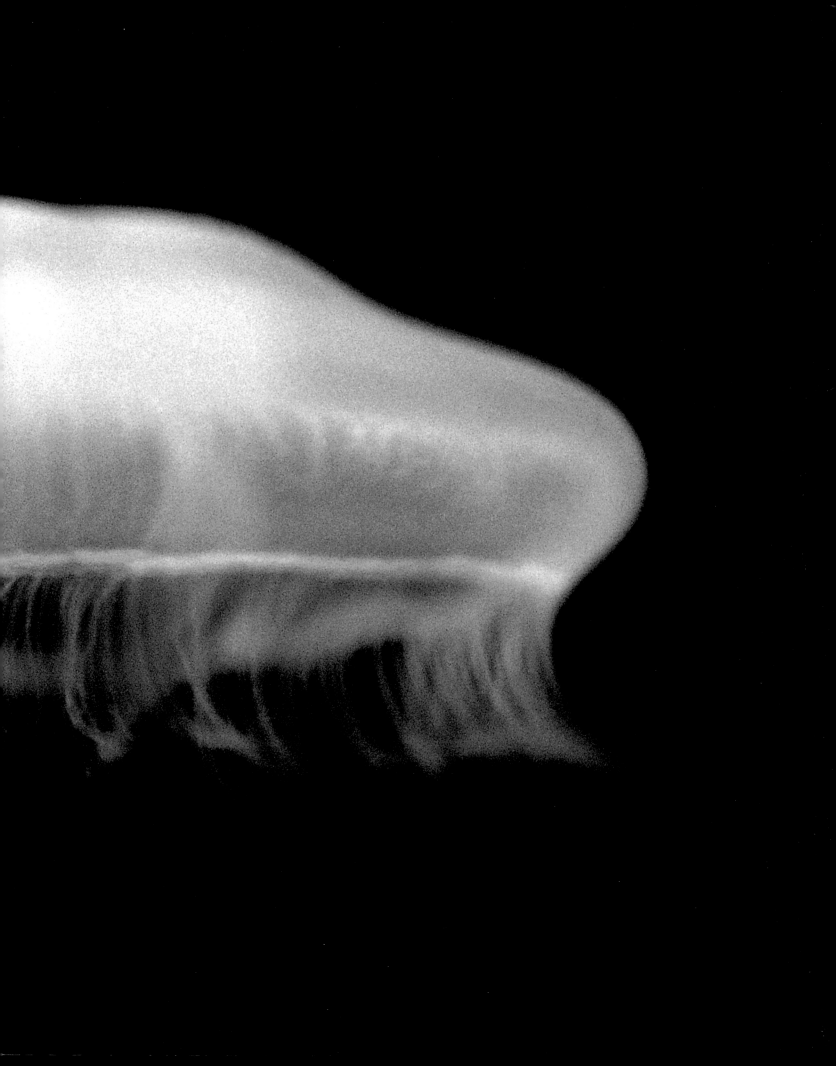

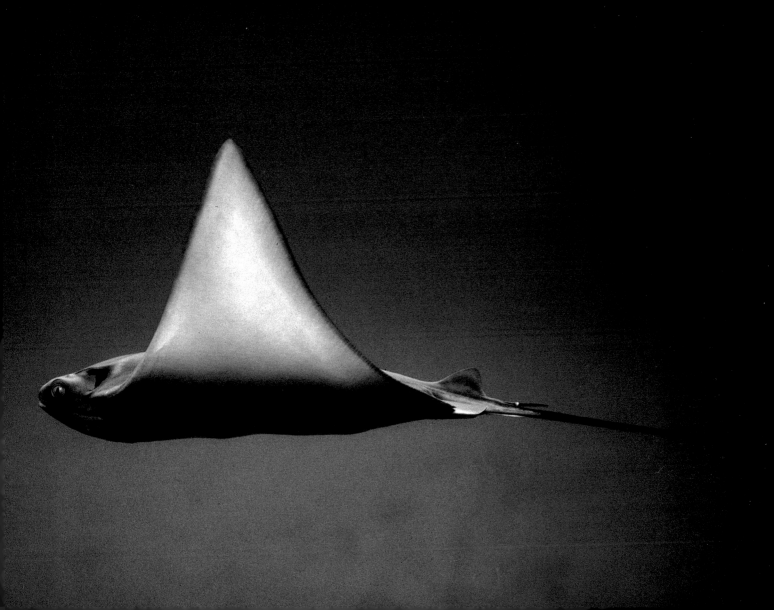

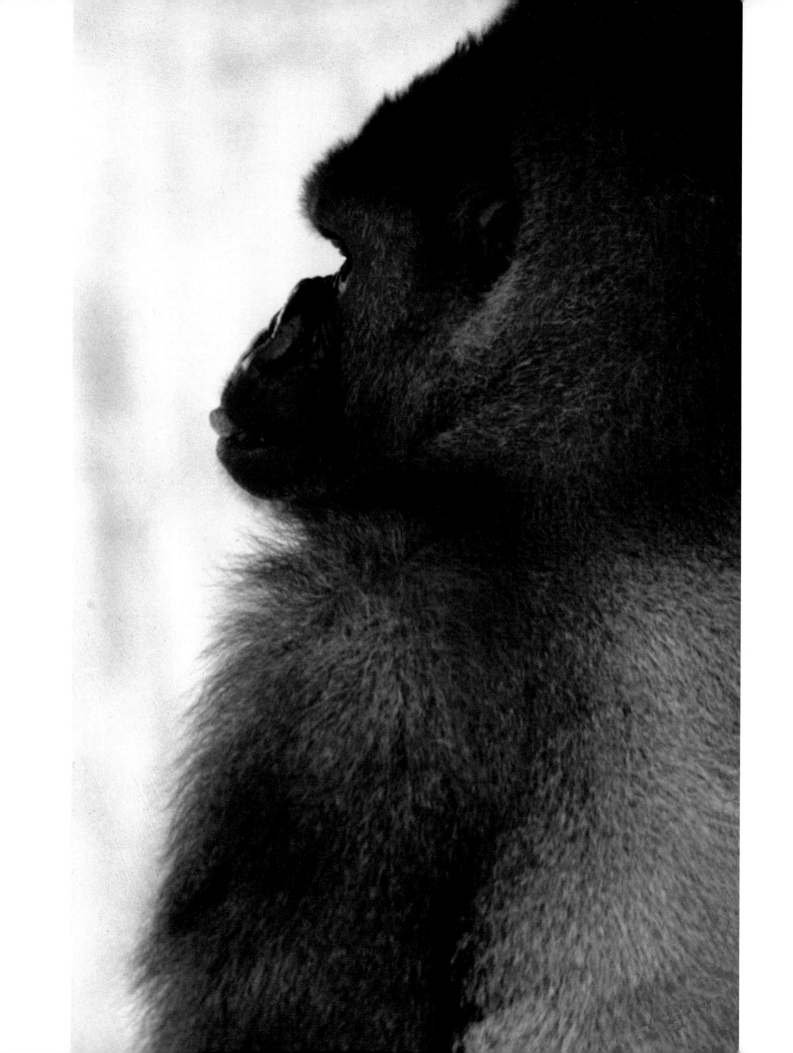

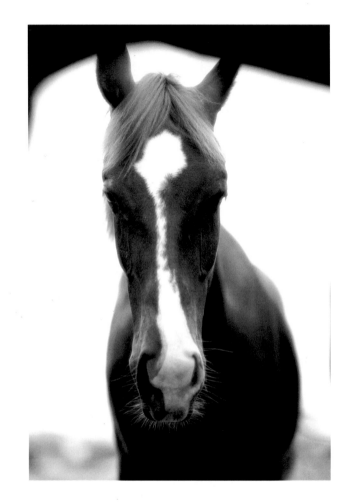

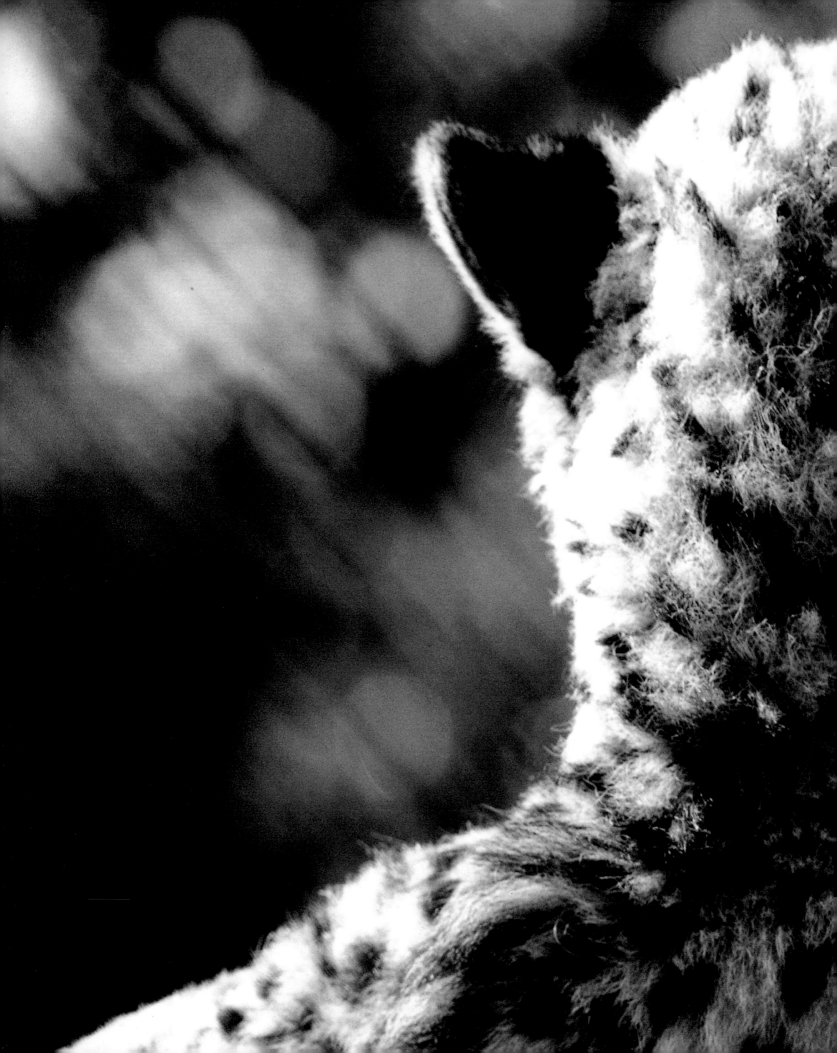

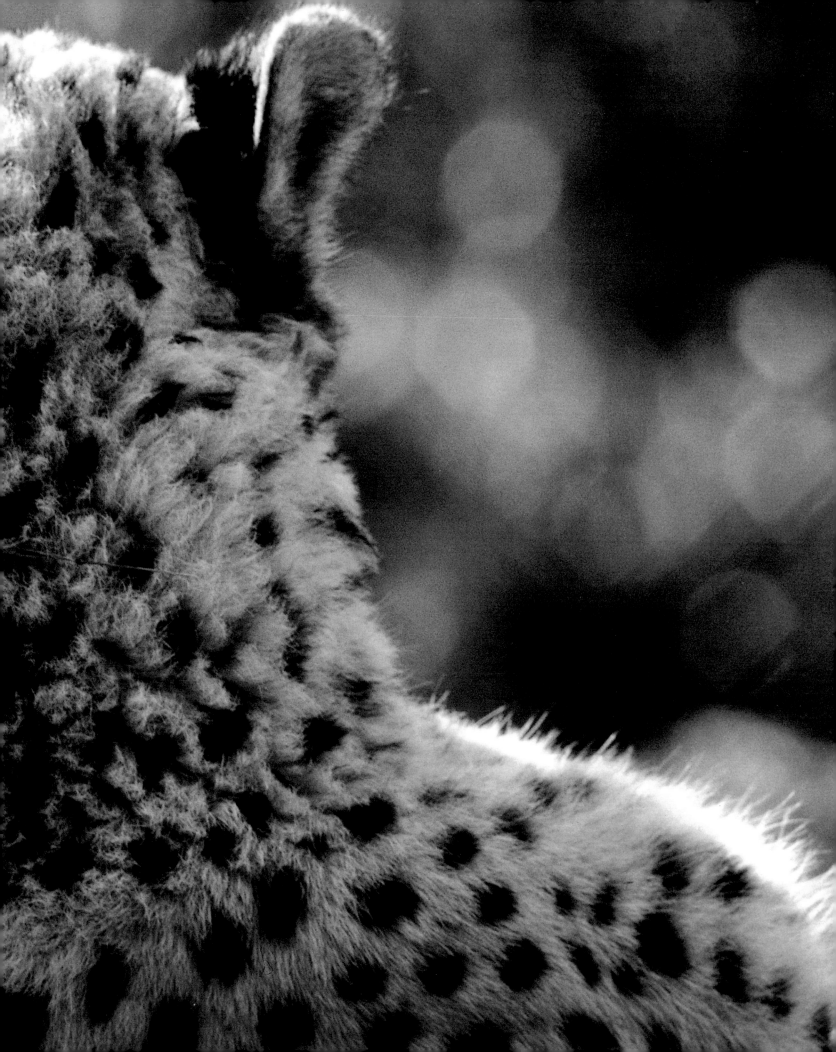

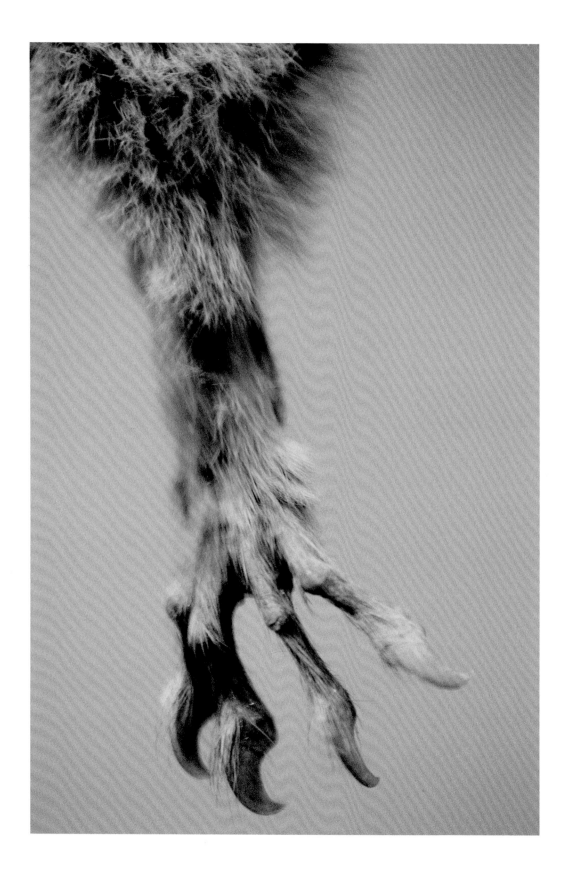

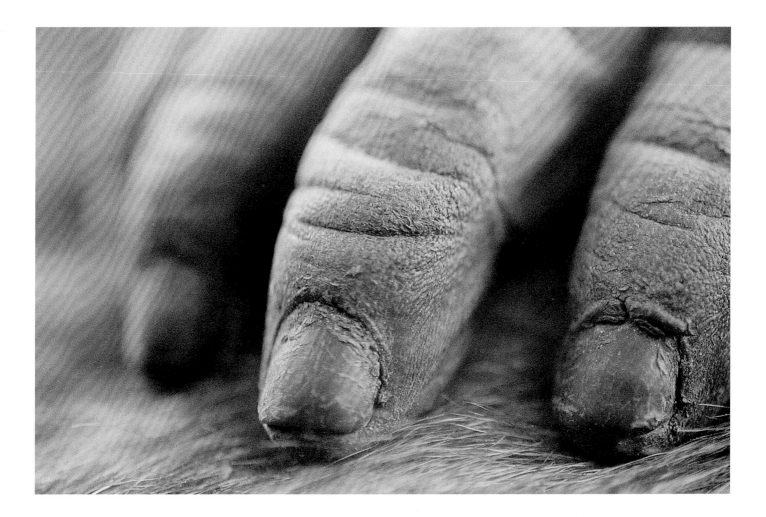

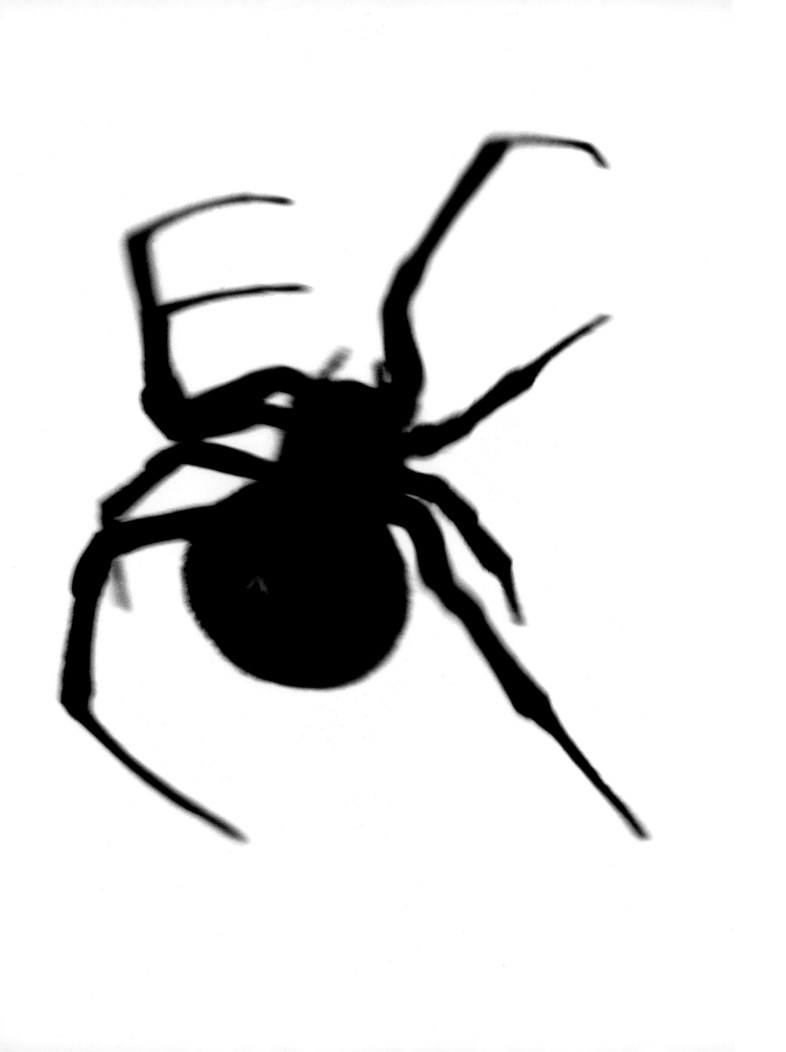

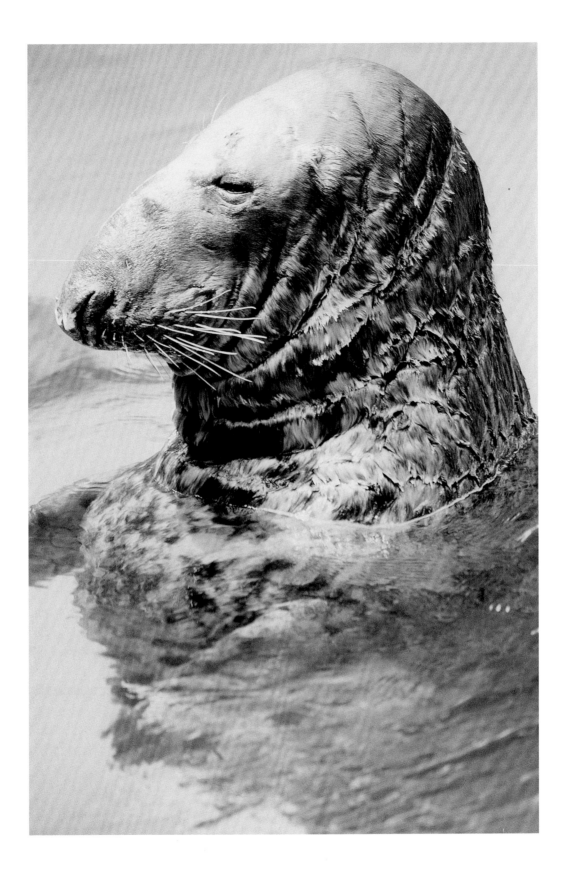

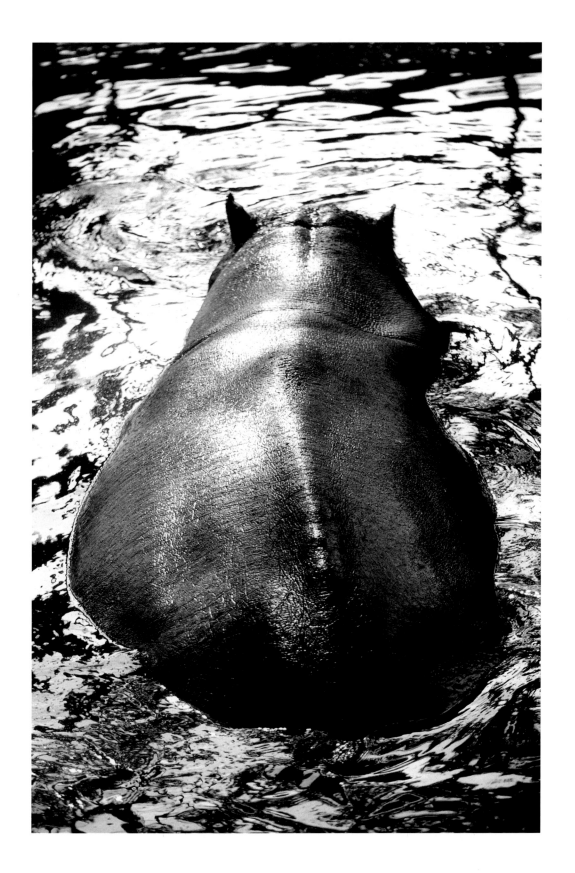

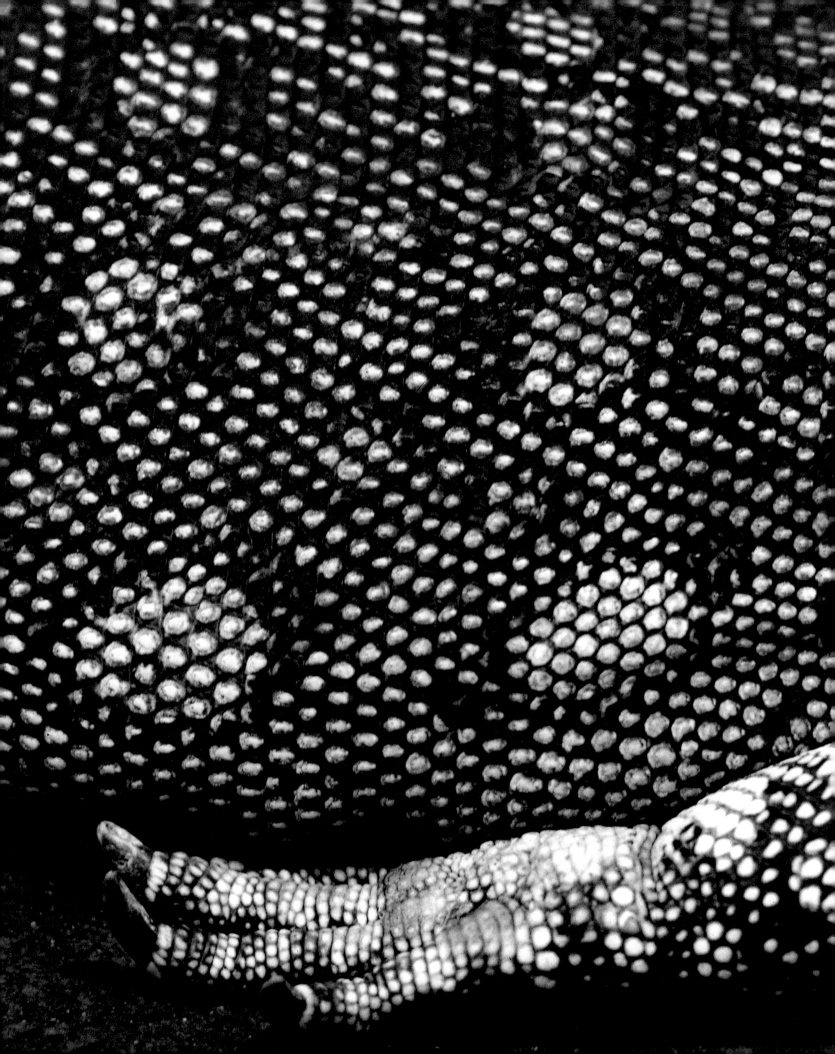

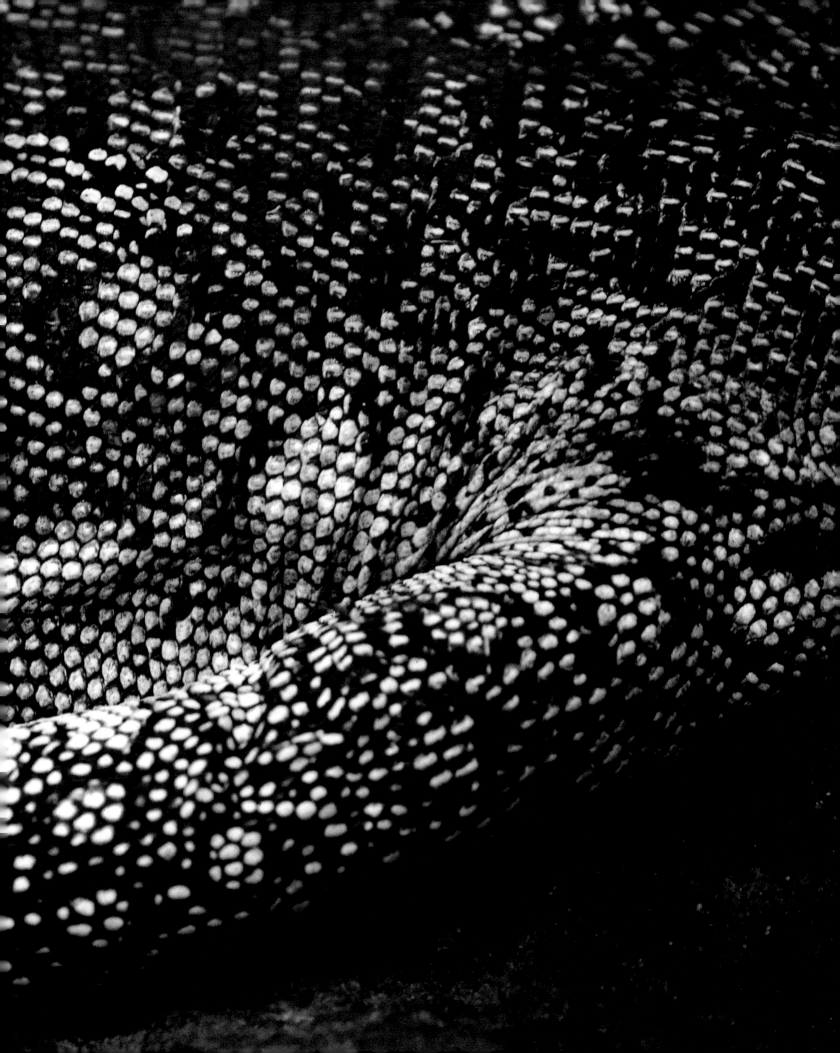

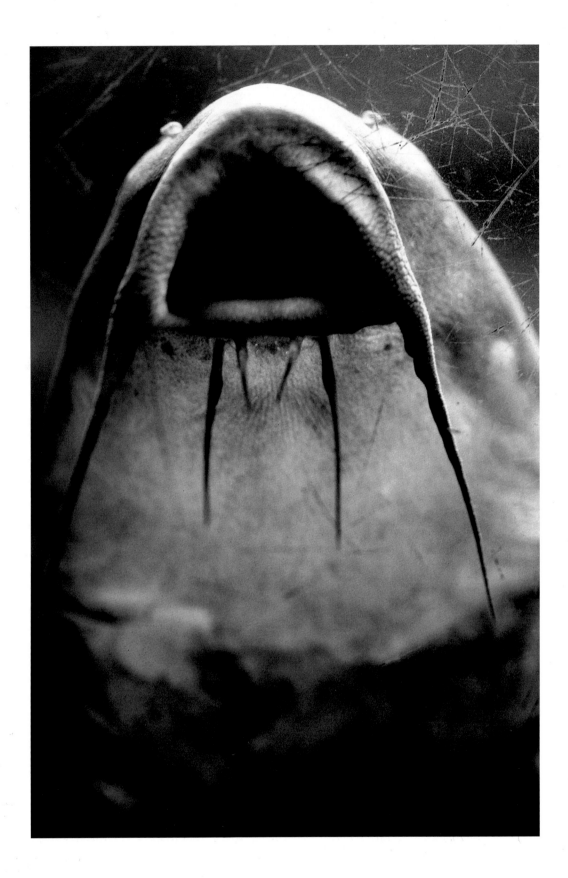

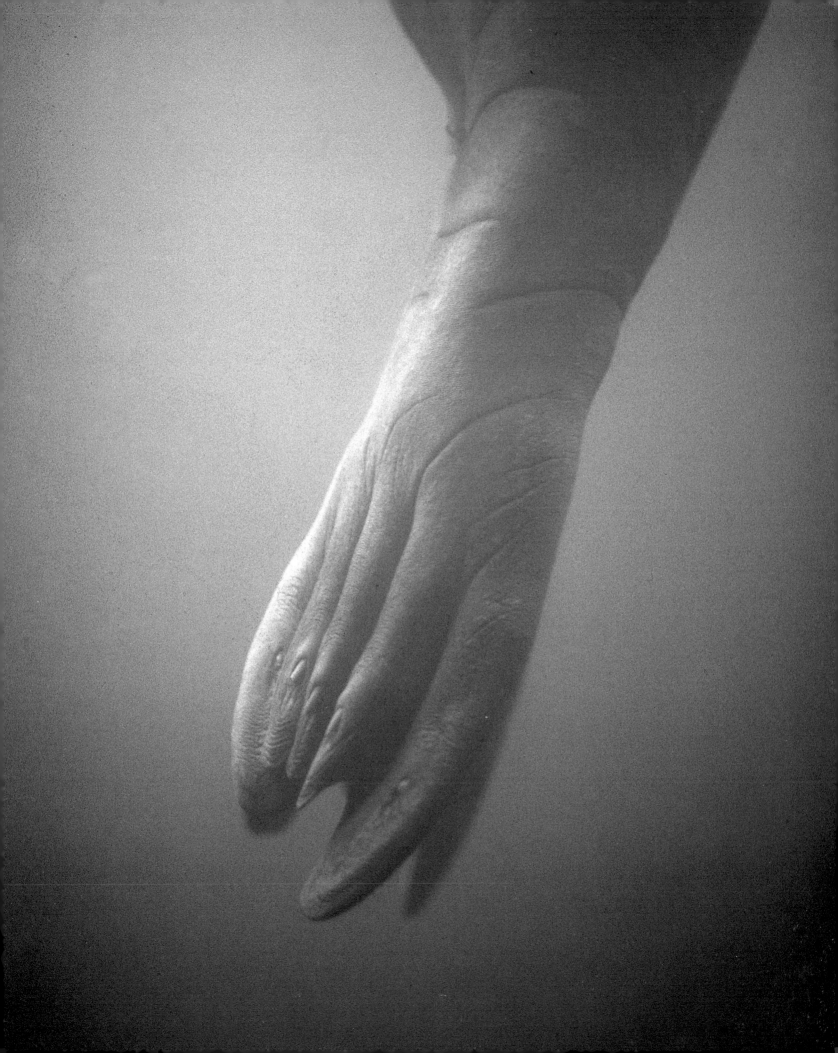

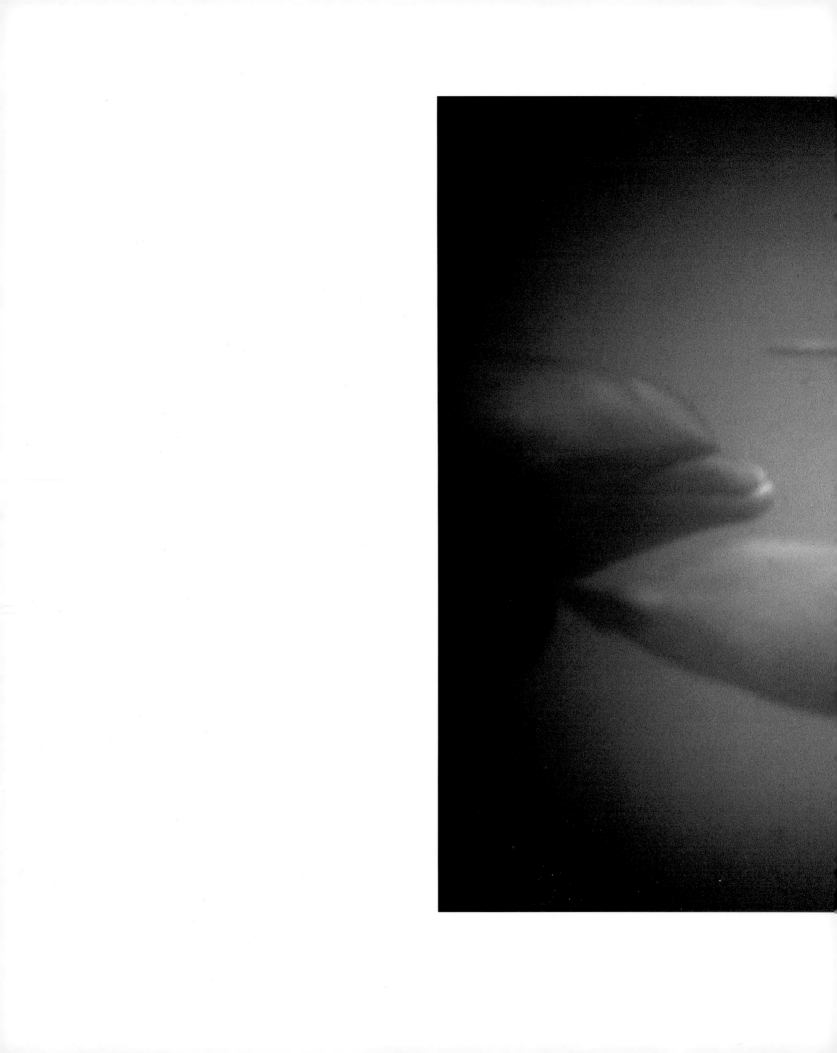

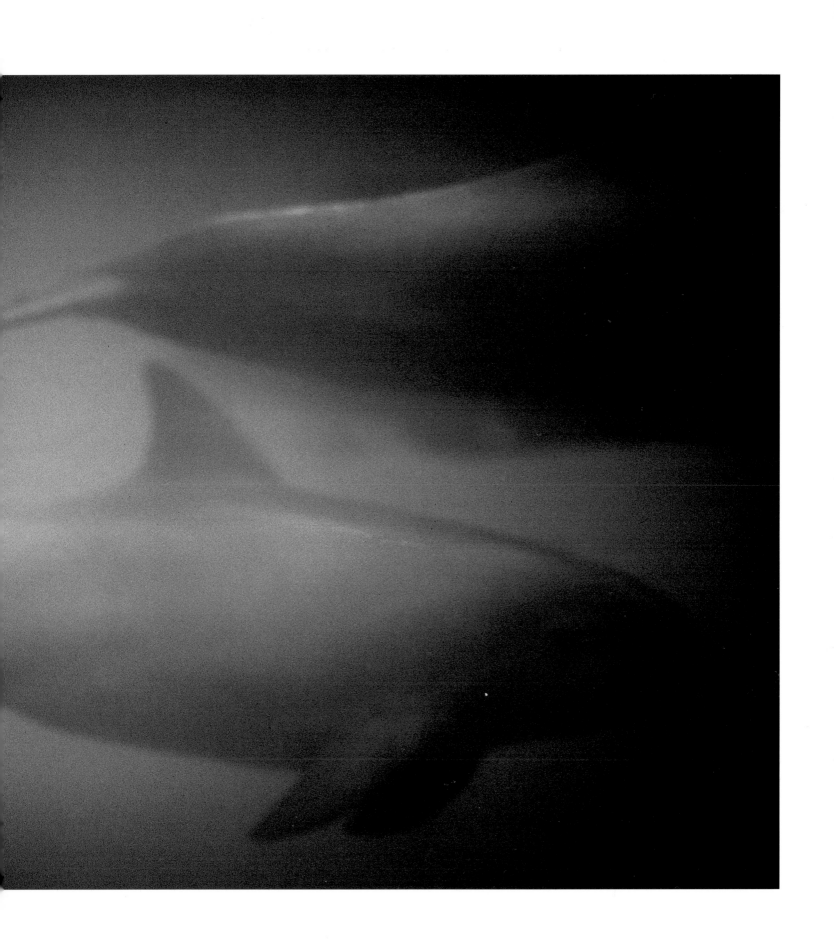

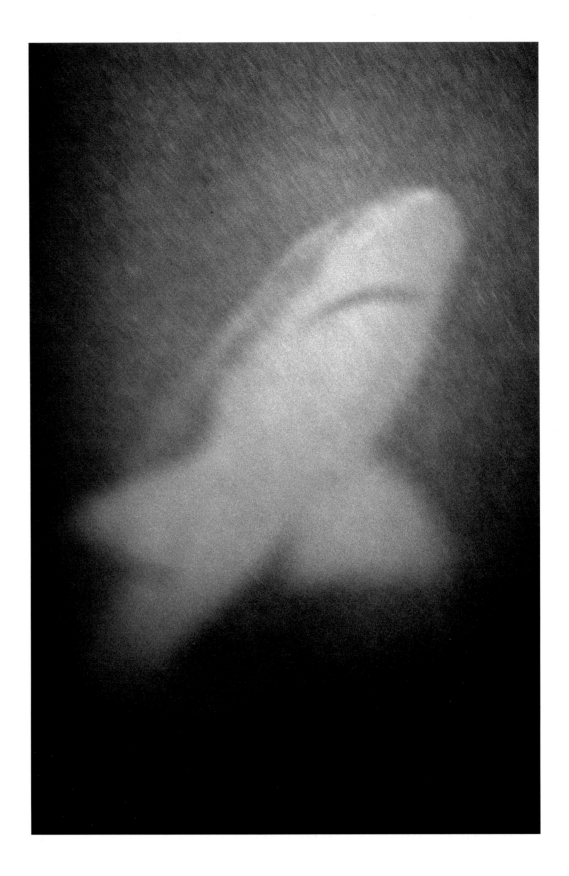

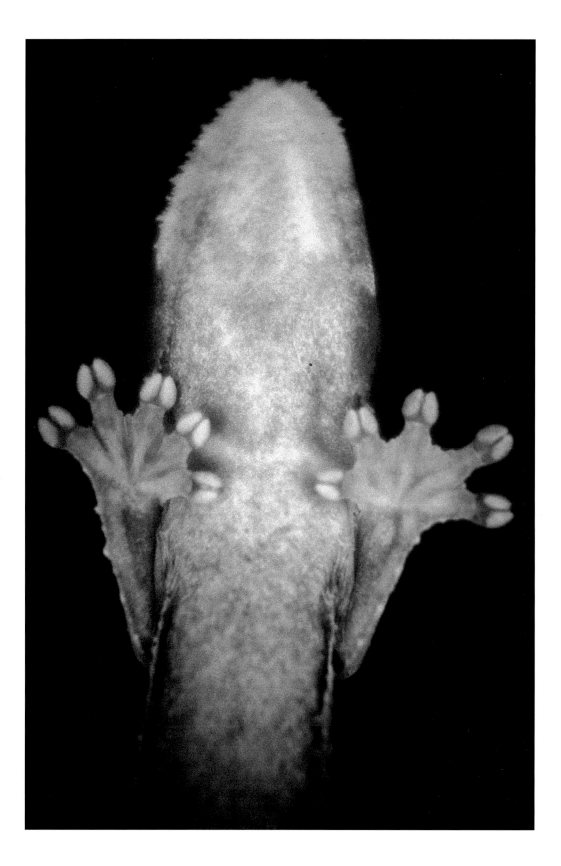

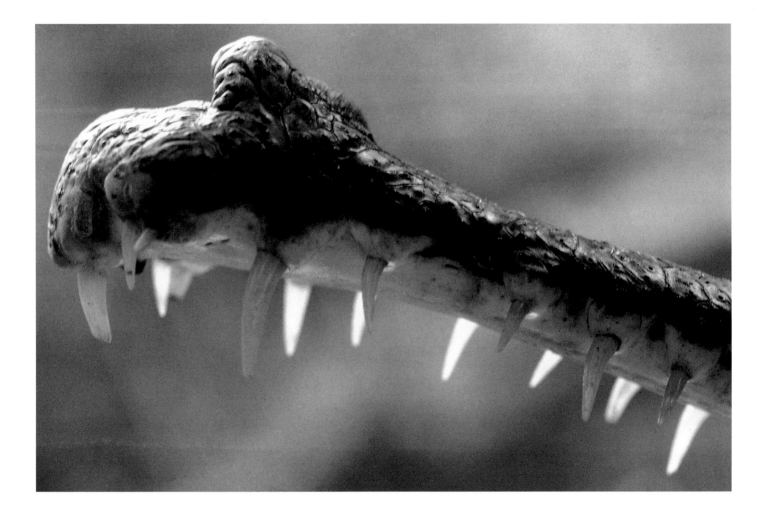

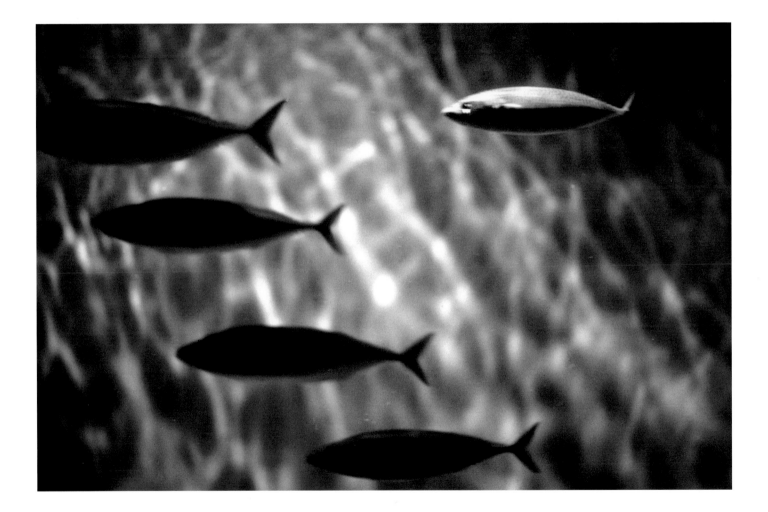

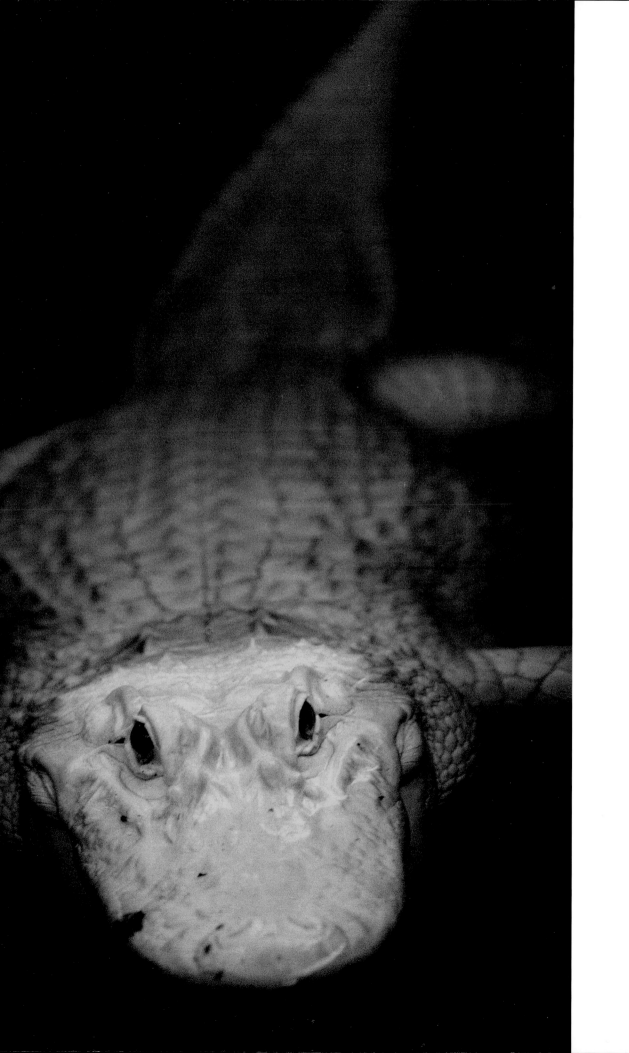

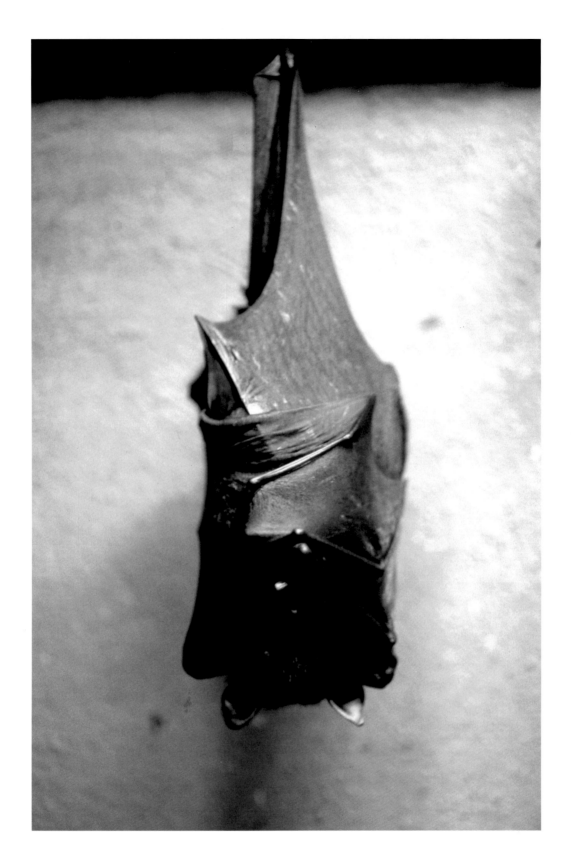

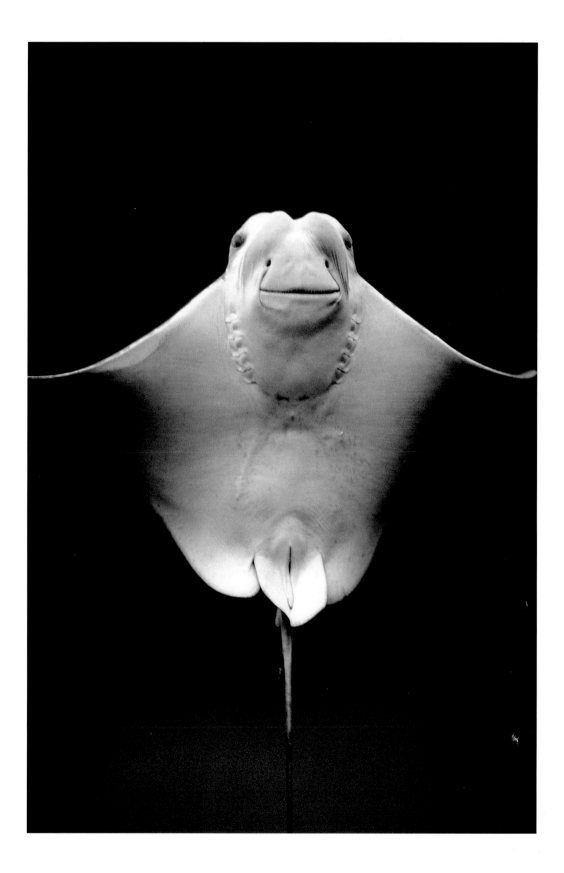

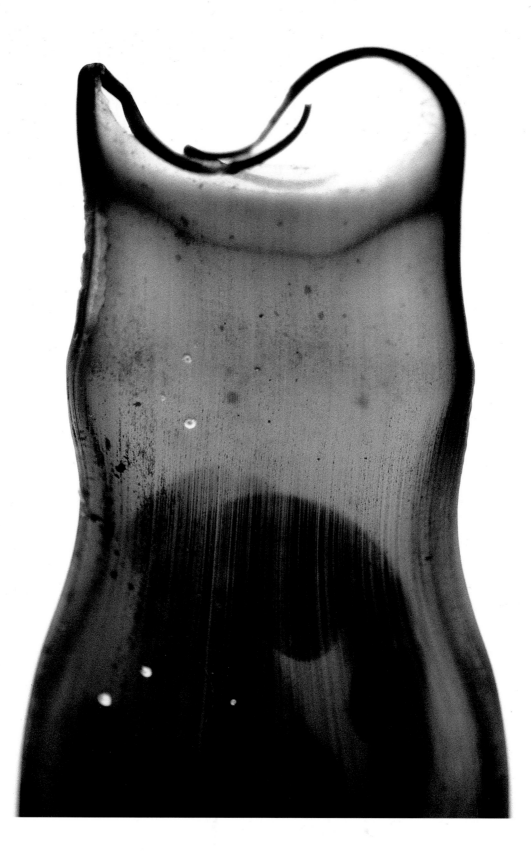

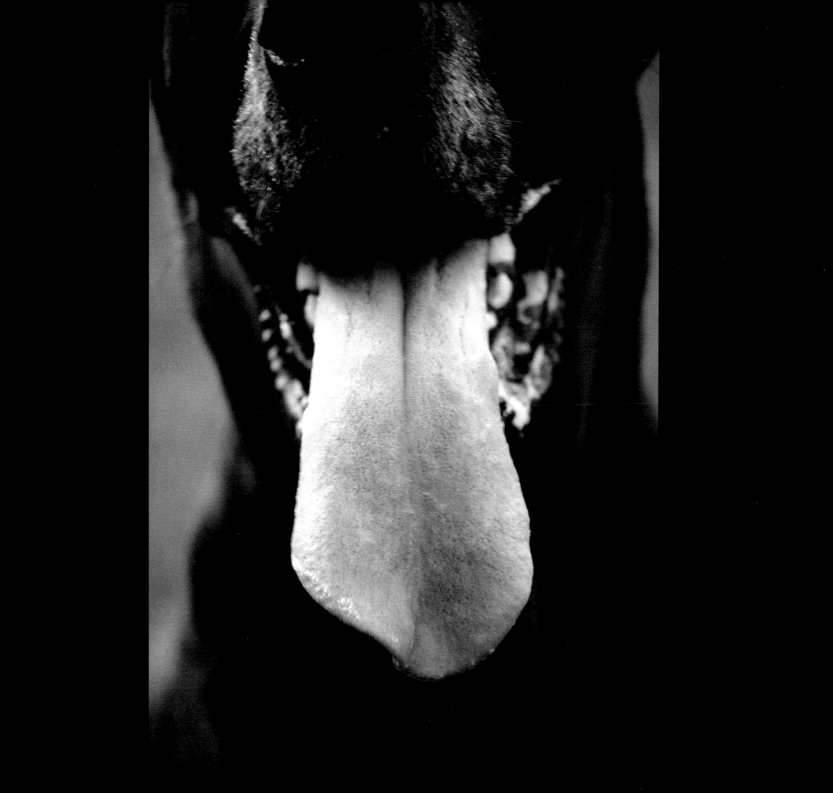

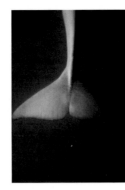

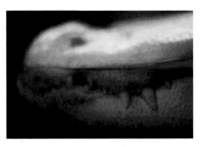

Komodo Dragon
Varanus komodoensis

Giant Gouramy
Osphronemus goramy

Beluga Whale
Delphinapterus leucas

American Alligator
Alligator mississippiensis

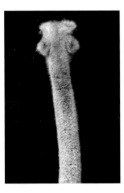

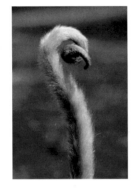

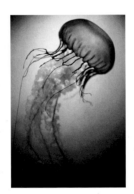

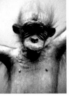

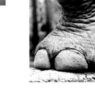

Ostrich
Struthio camelus

Black-handed Spider Monkey
Ateles geoffroyi

Sea Nettle
Chrysaora fuscescens

Orangutan
Pongo pygmaeus

Asiatic Elephant
Elephas maximus

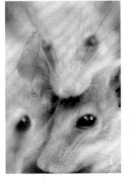

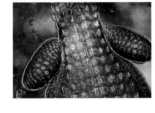

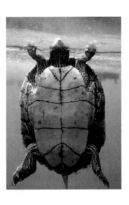

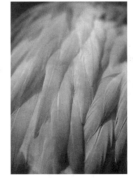

White Footed Mice
Peromyscus leucopus

American Alligator
Alligator mississippiensis

Texas Map Turtle
Graptemys versa

Greater Flamingo
Phoenicopterus ruber

Common Carp
Cyprinius carpio

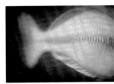

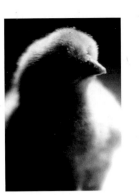

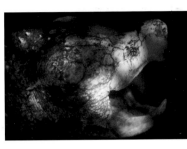

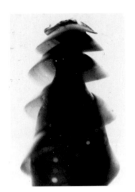

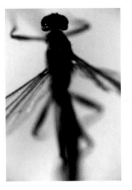

Common Carp II
Cyprinius carpio

Chicken
Gallus gallus

Gopher Tortoise
Gopherus polyphemus

Horn Shark Egg Case
Heterodontus francisci

Violet Tail Damselfly
Argia violacea

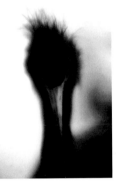

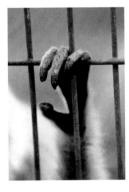

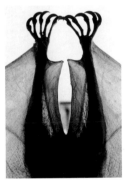

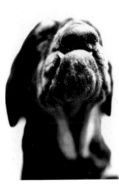

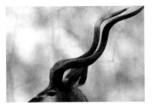

Little Blue Heron
Egretta caerulea

White-handed Gibbon
Hylobates lar

Flying Fox
Pteropus mearnsi

Mixed Breed Dog
Canis domesticatus

Greater Kudu
Tragelaphus strepsicerous

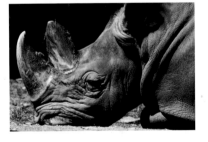

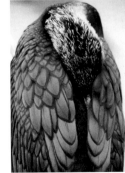

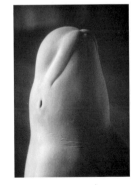

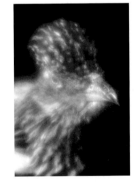

White Rhinoceros
Ceratotherium simum

Great Cormorant
Phalacrocorax carbo

Beluga Whale
Delphinapterus leucas

Greater Roadrunner
Geococcyx californianus

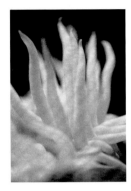
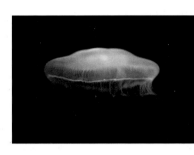
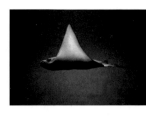
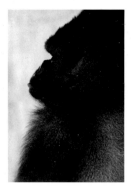

Anemone
Anthopleura

Black Duck
Anas rubripes

Moonjelly
Aurelia aurita

Bullnose Ray
Myliobatis freminvillii

Gorilla
Gorilla gorilla gorilla

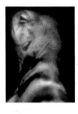
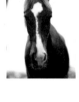
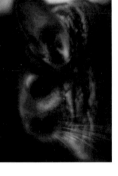
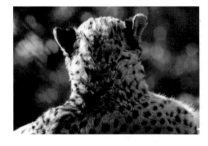
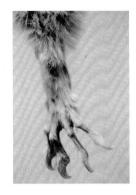

Curly-tailed Iguana
Leiocephalus carinatus

Horse
Equus caballus

Chinchilla
Chinchilla laniger

Cheetah
Acinonyx jubatus

African Tree Squirrel
Genus Heliosciurus

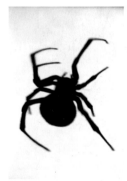
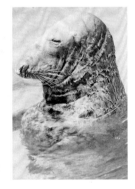
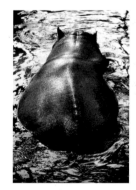

Mountain Gorilla
Gorilla gorilla gorilla

Black Widow Spider
Latrodectus mactans

Grey Seal
Halichoerus gryphus

Hippopotamus
Hippopotamus amphibius

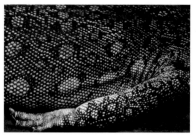

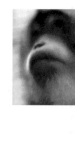

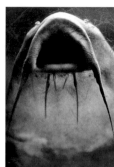

Nile Monitor Lizard
Varanus niloticus

Blue Catfish
Ictalurus furcatus

Rhesus Monkey
Macaca mulatta

Walrus
Odobenus rosmarus

Bottlenose Dolphin
Tursiops truncatus

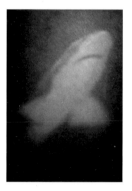

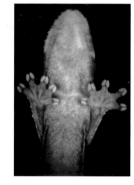

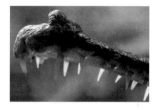

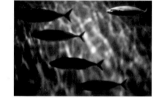

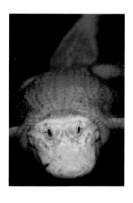

Bull shark
Carcharhinus leucas

Leaf-toed Gecko
Phyllodactylus xanti

Gavial
Gavialis gangeticus

Blue-fin Tuna
Thunnus thynnus

American Alligator
Alligator mississippiensis

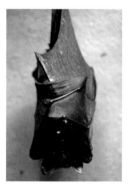

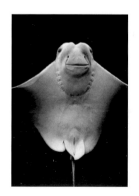

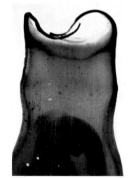

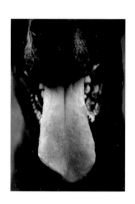

Flying Fox
Pteropterus mearnsi

Cownose Ray
Rhinoptera bonasus

Skate Egg Case
Raja sp.

Great Dane
Canis domesticatus

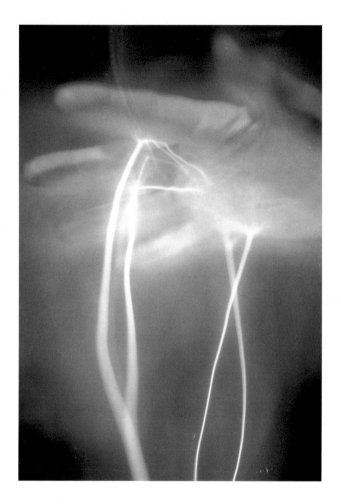

This book is for Andrea, my favorite creature.